ART
SLEEVES

RIZZOLI NEW YORK

New York · Paris · London · Milan

DB Burkeman

ART SLEEVES

Album Covers by Artists

Published by
Rizzoli International Publications, Inc.
300 Park Avenue South
New York, NY 10010

www.rizzoliusa.com

Compilation and text: © DB Burkeman

Additional copyrights in back of book

2021 2022 2023 2024 / 10 9 8 7 6 5 4 3 2 1

Publisher: Charles Miers

Design: Philippe R.

Rizzoli Editor: Julie Schumacher

Project Manager: Costanza Prandoni

Production Manager: Colin Hough Trapp

Photography: John von Pamer

Photo Editing: Max Burkeman

Design Coordinator: Olivia Russin

Managing Editor: Lynn Scrabis

Printed in China

ISBN: 978-0-8478-6887-2

Library of Congress Control Number:
2020934585

*Front and back cover art, clockwise
from front left to back cover:*
Barry McGee for Towa Tei; Peter Saville
for New Order; Richard Phillips for No
Joy / Sonic Boom; Christopher Wool for
Day and Taxi; Chris Johanson for Tussle;
Tom Hingston for Young Fathers; Amanda
Demme for Andrew Bird; The Designers
Republic / Weirdcore for Aphex Twin;
Richard Prince for Lee Ranaldo; Christopher
Wool for Day and Taxi; Margaret Kilgallen
for Tommy Guerrero; Tauba Auerbach for Zs;
Pushead for Saigan Terror / Stompede.

Note:
LPs, singles, and CDs are not true to size.

For my son, Max Burkeman.

Table of contents

DB Burkeman
Judging by the Cover

This is not an academic thesis, it's simply a love letter to art and music.

I've been music-obsessed since before I was even a teen. I would fall asleep with a transistor radio under my pillow, trying not to let my parents hear it but hoping to hear a song by the bands I loved or, even better, a new release by them!

Growing up in London, when I was old enough to spend my paper-round and pocket money in record shops, the image on the front of the record was as important to me—if not more—as the music contained within it.

Of course, this resulted in a lot of bad choices, and while my collection may have possibly looked "cool" to my uneducated friends, it had some truly terrible music in it. This does, however, illustrate how significant and influential the record cover has been on me.

As a rave and club DJ, the visual importance of a sleeve became painfully apparent to me when most DJs started switching from vinyl to playing digital files—I simply couldn't do it. Scrolling on a screen and only seeing text made it impossible for me to DJ with the same intuitive feeling that I had flipping through records—physically handling and looking at the sleeve provided me with enough of a visual cue to have an emotional response. Even if it was a promo white-label 12" that had a scribbled title, name, or doodle on the cover, it was enough to remind me how it sounded and felt.

In heated moments during our 30 years together, my wife, Wini, has been known to call me a hoarder. I'll counter in defense with such pretentious labels as "passionate collector" or even "amateur archivist." In truth, I'm grateful to her that she has lived, for all these years mostly happily, with all my stickers, books, records, and various other bits and bobs. The result of my obsession with music and ephemera is what lead to the creation of the book you are now holding in your hands.

I need to make it clear—this is not a "history of album art" type book. There actually have been some very impressive books published recently that attempt to catalog the entire history of art on album sleeves. They are massive tomes, but, ultimately, they fail for me because to show 80 years of history and thousands of sleeves in one book is simply an impossible task. *Art Sleeves* is simply a tightly curated selection of works that I think are important because they are beautiful, powerful, obscure, or noteworthy for other reasons such as the significance of the artists that created them. I should also note that most of the album art books that have come before focus only on vinyl. While I appreciate the romanticism of this as my own personal dislike for the CD as visual format is strong—one cannot discount the artworks that have been made to house CDs—and even cassettes.

There was a period in the '90s through the '00s when many labels simply stopped producing vinyl, and some great artworks were only available as CD covers. So while this book is inclusive in that way, I also had to make

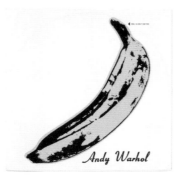

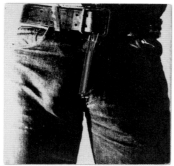

Andy Warhol
Velvet Underground & Nico
The Rolling Stones

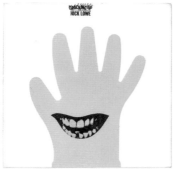

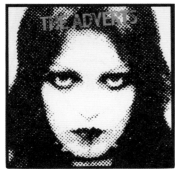

Barney Bubbles
Nick Lowe
The Adverts

some hard decisions to leave out many of my personal favorite sleeves albums—some because we could not obtain permissions from the artist or label, some because they have already been so well documented, including Warhol, Haring, and even Basquiat. That being said, Warhol's *Velvet Underground & Nico* and the Stones' *Sticky Fingers* rank in my top album covers of all time. Both have a playful physicality while also being cleverly sexual.

When I started to think about the idea of a record cover book, the most daunting question was: Where and when to start? I decided to kick off with the post punk era—specifically, the UK in 1980—for two main (and obvious) reasons: One, punk rock had ushered in DIY culture to the music business, thus, for the first time, giving the power of aesthetic decision making to the bands and artists, not the labels. Obviously, there are exceptions to this dating back to the '60s, but generally speaking, musicians had little say in the visual creative process with their labels. Starting in the late '70s, independent record labels and their distribution channels were having a moment—for the first time, they offered a credible alternative to the mainstream music channels that had, until then, dominated the industry.

The prime example of this is Rough Trade, a record shop focusing on punk rock owned by drama teacher Geoff Travis, which opened its doors in 1976. Travis then began to manage some bands, and in 1978, he opened the label Rough Trade Records, which was informed by left-wing politics and structured as a cooperative. Within months, Rough Trade also set up a distribution arm that serviced a network of independent record shops across the UK that became known as The Cartel. Hundreds of tiny DIY labels sprang up, and then the weekly music paper *New Musical Express (NME)* started the Indie Chart, a must-read and must-listen for any self-respecting anti-mainstream type.

Even though hippy culture and the new punk generation were polar opposites in many ways, left-wing hippy designers were incredibly involved and impactful in the birth and shaping of punk rock's aesthetic. It makes sense, though—they were all outsiders of the commercial mainstream and immersed in counterculture creativity already. Two long-haired hippy-type designers in the UK dominated and most influenced the early punk and the new indie-DIY design aesthetic. The most well-known was an anarchist with connections to the Situationists, Jamie Reid, with his cut-and-paste ransom note-style graphics for the Sex Pistols. The other is my personal design hero and former psychedelic lighting and visuals guru Barney Bubbles (real name Colin Fulcher, 1942–1983), who was responsible (although uncredited) for all of Stiff Records' output. It's a true creative (and human) tragedy that he ended his own life at age 41.

Punk rock is, in its essence, at the root and route of so many of today's artist practices. Barry McGee, my favorite painter, alerted me to a 1988 sleeve titled *The Thing That Ate Floyd* that he'd contributed to for an underground Bay Area punk label. It was credited on the record to his graffiti tag, Twist, so those of us who collect McGee ephemera and multiples never knew of its existence.

Visually, my favorite record label of the '80s (and probably still ranks today) was Factory Records. Peter Saville and his team were creating brilliant works of art on record covers. Below is an excerpt from Matthew Robertson's magnificent book on the label, *Factory Records: The Complete Graphic Album*. He nails it when he writes:

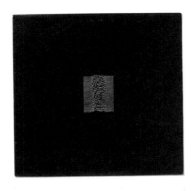

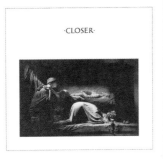

Peter Saville / Joy Division
Joy Division

Peter Saville / Bernard Pierre Wolff
Joy Division

Malcolm Garrett / Linder Sterling
The Buzzcocks

Malcolm Garrett
The Buzzcocks

From the beginning, Factory was more of a collective of like-minded individuals than a structured business—profitability was always a secondary concern. This freewheeling approach to the business of running a record label, whereby the rules were made up as they went along, probably meant that Factory was destined to disintegrate from the outset. In many ways, it is a wonder that it lasted as long as it did. Its unconventional approach extended to not signing contracts with artists and avoiding promotional duties; co-founder Tony Wilson, originally a Granada TV presenter, saw Factory as "a laboratory experiment in popular art." Its survival was propped up by the success of its major acts Joy Division, New Order, and the Happy Mondays.

The catalyst behind the formation of Factory was the Punk movement of the 1970s. This cultural rebellion sought to break down barriers and give everybody the opportunity to participate in intellectual and/or aesthetic production on their own terms, irrespective of any formal "talent" or "skill." Untrained musicians were empowered to form bands, while untrained designers could produce the artwork. While Punk had a strong collective esthetic, the defining characteristic (and most important lesson) of the age was this DIY-do-it-yourself-ethos.

When first seeing the few examples of the Factory sleeves on pages 170–173, they took my breath away, confused me, or simply made me want to hang them on the wall.

Not having any formal art education has been a hindrance in many aspects of my post-DJ career in the arts and publishing worlds. However, in some ways I feel it has freed me up to make my own opinions and assumptions of what art is and what makes it good. This also informs my feelings on graphic design. Many argue that graphic design is not real art, but I disagree. There are graphic designers included in the book, some of which have had as profound an effect on me as seeing the Rothkos at the Tate museum for the first time. In fact, looking back, most of the album covers that first had a powerful impact on me were by graphic designers rather than gallery-represented fine artists. Storm Thorgerson and Aubrey Powell for Hipgnosis blew my young, hallucinogenic-fueled mind with their Pink Floyd and Led Zeppelin sleeves; and then Barney Bubbles, Peter Saville, and Malcolm Garrett as punk rock, post punk, and new wave emerged and became my world.

In the '60s, there were a few American West Coast, hippie, or counter-culture graphic artists who did records, including Robert Crumb and Rick Griffin, who were alternative comic book artists, and hot-rod car culture hero Ed Roth. And even though I had no love—or close to none—for the music that the art was made for, these sleeves had a huge visual impact on me. In fact, in 2000, when I needed a redesign of the heart and bones logo that I adopted as my DJ identity/logo, I asked my designer friend Gabriel Hunter if he could do it in a Rick Griffin style. (The logo now adorns the spines of my books.) Sadly, Griffin died young in a motorcycle accident, but Crumb and Roth both went on making art for records for many years. See The Birthday Party's 1982 *Junkyard* on page 163.

One of our missions with the book is to show obscure or artisanal hand-embellished sleeves. For Rita Ackermann's *When Sunny Expands* (p. 25), it looks as if she dipped her hand in red paint and applied it randomly to each of the 100 unique sleeves. Martin Creed hand-painted five hundred sleeves, all with the same design but in different colorways (p. 49).

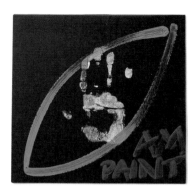

Richard Russell / Lee "Scratch" Perry
Residence La Revolution

Richard Russell and Lee "Scratch" Perry collaborated as Residence La Revolution on "I Am Paint" (p. 168), staying up all night finger (and feet) painting 250 sleeves. The record itself was never for sale, but it could only be acquired by "bartering" a handmade gift. However, sending an item in did not guarantee any return, which added uncertainty and emotion to a previously straightforward exchange. I recruited my daughter Eve to help me paint Richard's name as a Run-DMC logo flip, sent it in, and hoped for the best.

The UK's Vinyl Factory has definitely figured out that there's a massive audience and market for limited-edition art type records. Founded in 2001, the enterprise encompasses a record label, vinyl pressing plant, record shop, music magazine, and gallery spaces. Just to buy a few VF records to show in this book, I needed to spend a small fortune—probably enough to fund an impressive collection of regular records! But some are literally 12" pieces of art. Thankfully, VF was very helpful, providing high-res images of records we couldn't track down.

One VF project that totally blew my mind featured artist Christian Marclay and London's White Cube gallery. In 2015, for over three months, Marclay staged live music performances at the gallery with many of the world's most respected experimental musicians/artists. VF set up a mobile pressing plant on-site so that the performances were recorded and cut direct-to-disc and pressed onto vinyl live, right then and there! At the same time, Marclay's visual art was being reimagined as record covers by Coriander Press, who had brought a screen-printing press to the gallery. Week after week, VF released an edition of five-hundred live-printed albums—sleeves and live-recorded and live-printed records—for each of Marclay's 15 performances (pp. 118–119).

In researching this book, I discovered possibly one of the rarest records ever, a true holy grail. Surprisingly it's by one of the biggest, most important bands on the planet, yet few even know it exists. While chatting via email with Stanley Donwood, he mentioned that he and Radiohead had done a one-of-one 12" record and sleeve for a Thom Yorke remix: "As far as I can remember, we made an etched zinc plate and printed it black on a gold card 12" sleeve. We letterpressed the center labels, too." I wonder where that is now!

Personal

The curating of this book was simultaneously fun and torture. I've been a vinyl junkie/collector since the '70s, but once I started working on *Art Sleeves*, the book gave me a "legit" excuse, and the dope-fiend habit grew exponentially out of control.

The process for selecting sleeves to include in the book was somewhat haphazard because we kept discovering new ones, making less room to include the classics we'd already decided on. It became a game of Tetris, with the designer and editor losing their minds as we showed them more and more that they already did not have room for. The question that kept plaguing us was whether it was more important to show famous artists or lesser-known artists with fantastic sleeves—we did our best to find a balance.

For me and my project manager, Costanza, the most frustrating part of the book's creation was getting denied permission to reprint sleeves that we

Tauba Auerbach
Hiro Kone

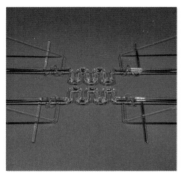

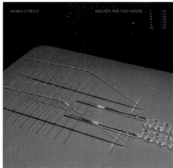

Tauba Auerbach
Meara O'Reilly

really wanted to show—why would an artist not want their art, that they had made for a record, not shown in a book about art on record covers? I also had to exclude a number of artists that I wanted in the book because the gallery representatives or record labels either never responded, asked for exorbitant fees, or simply denied the use—apologies for those omissions (and please don't write in saying: how could you not include Mickalene Thomas, Banksy, Daniel Arsham, KAWS, Nan Goldin, Robert Crumb, Mike Kelley, Martin Kippenberger, Robert Mapplethorpe, Kanye West, Dennis Morris, Jenny Saville, Julian Opie, Laurie Anderson, Paul McCarthy, Sarah Lucas, Peter Doig, Robert Frank, Elizabeth Peyton, Roman Signer, John Currin, William Eggleston, Willo Perron & Associates, etc. Maybe that's the next book).

Frustration from permissions denied led to the cancellation of a section on controversial sleeves—ones that were either banned at the time of release or examples of ones that never even made it to the marketplace because of conservative record company agendas. In this day and age, this unsurprisingly proved too controversial to pull off. One such art sleeve that really must be mentioned is Robert Williams' 1979 painting *Appetite for Destruction*, which was used for Guns N' Roses' 1987 breakthrough release.

Tauba Auerbach (pp. 30–33) is one of my absolute favorite artists, and she's definitely the smartest out of those favorites. She's like a mix of math genius, psychedelic shaman, and mad scientist. After we'd finished the interior layouts, she alerted us to a new Hiro Kone record that she'd just finished the artwork for. Then as soon as we added the image to my essay, Lee Ranaldo happened to ask if we'd seen the sleeve Tauba had also done for *Hockets for Two Voices* by Meara O'Reilly—luckily, both fit and are shown here.

It warms my jaded heart that OG blue-chip legend Ed Ruscha still allows his work on sleeves! Thanks to poet/producer/designer David Breskin for contributing a text to this book and album designs he created using art by Glenn Ligon, Andrew Masullo, Simon Norfolk, and Ruscha's *DIRTY BABY*.

One of the questions I was most curious about when doing the Q&As with artists was what the first sleeve they remember having a real impact on them was? For me, it was the Blind Faith sleeve, owned by my best friend's dad. The cover had a surrealist photo by Bob Seidemann of a topless young girl in a field holding what looked to me like an alien spacecraft. This is, of course, another example of an album cover banned in the US and also one we couldn't show because of exorbitant permission cost. I also liked my mom's Beatles "White Album"—there was nothing on it, and I thought that was weird but cool, even as a kid.

Discounting the frustrations, its been a real joy making this book—actually somewhat unreal. The fact that the title "author" now gets put in front of my name is both surreal and somewhat of an inside joke. Anyone who knows me well knows that I'm actually not far from illiterate, having dropped out of formal education with severe learning disabilities at 14.

I type with one finger while spellcheck attempts to fix my butchered words. I am very lucky to have found a life in music, first as a DJ and then—because others valued my ears—as A&R for record companies. Thank goodness the music business didn't care about education and exam results, or I might be homeless rather than collecting records and publishing books.

Sleeve as muse

Something I have always loved in popular culture is when an artist reinterprets or subverts an already cool (or terrible) piece of art or design to make it their own.

In 2003, Tony Arcabascio helmed a project while he was a partner in Alife titled "Heavy." Very simply, he went to a bunch of his favorite artists and asked them to reimagine one of their favorite album covers. The artists physically painted on the covers. The results varied from silly to genius, ugly to stunningly beautiful! They were collected into two-volume books that came with a vinyl compilation of local bands. Shown here are just four of my favorites, plus Todd James (p. 91).

Next are examples by Christian Marclay (below), Dave Muller (p. 12), Eric White (p. 16), INVADER (pp. 14–15), Alex Da Corte (p. 18), and David Ellis (p. 22)—six fantastic artists who let the sleeve be their muse or physically incorporated them into new works.

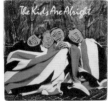

Russ Karablin
HAZE
Deanne Cheuk
Barry McGee

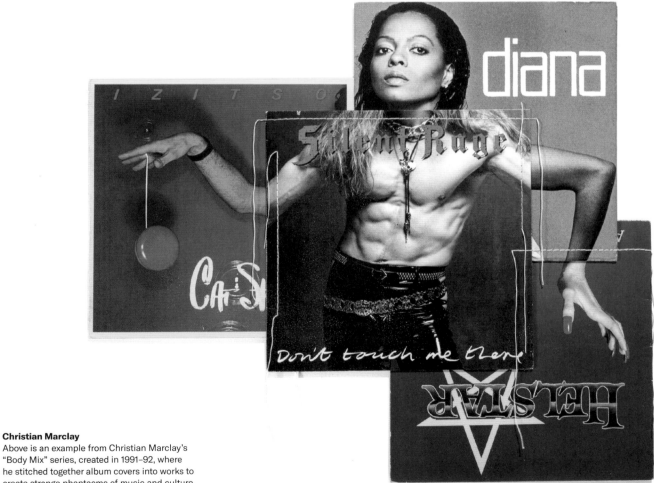

Christian Marclay
Above is an example from Christian Marclay's "Body Mix" series, created in 1991–92, where he stitched together album covers into works to create strange phantasms of music and culture that bring to mind surrealism's exquisite corpse.

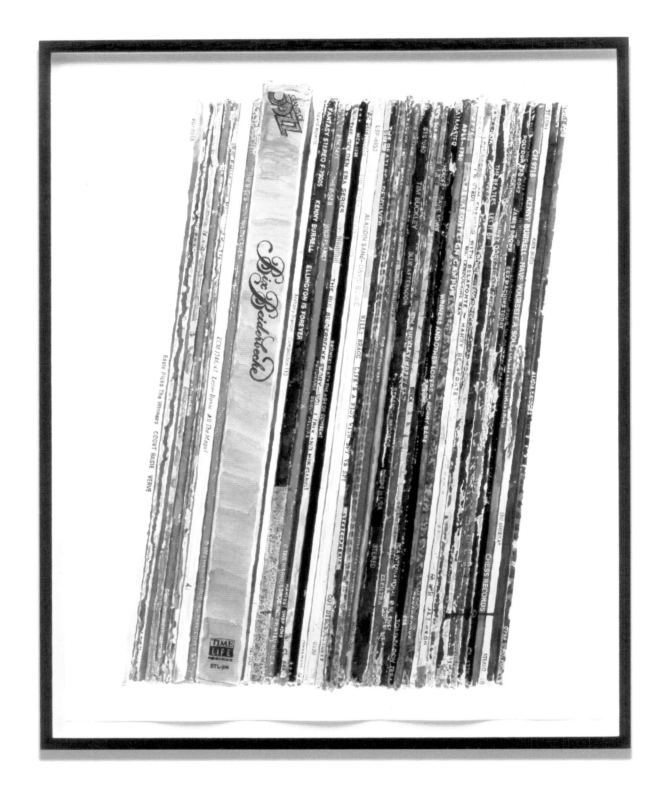

Dave Muller
Among the variety of styles of work that Dave Muller creates around his love of music are gigantic acrylic paintings on paper that show the spines of a collector's album covers. They feel very personal and give a snapshot into the person's life.

Dave Muller

What is your earliest memory of a record sleeve?

I was with my parents when they bought a copy of *Magical Mystery Tour* at the drugstore when I was four or five years old. I remember seeing it on a display rack, maybe next to *Their Satanic Majesties Request*...

How old were you when you first noticed or fell in love with a record cover?

I started listening to records on a portable record player in my bedroom when I was six or seven years old. I listened to The Kingston Trio's *At Large* over and over again. Not sure if I fell in love with the cover, but I spent a lot of time looking at it.

Do you still like that record?

Not nearly as much as I did then.

When I was young, I actually bought records simply because of how cool the sleeve looked to me. Did you ever buy a record simply because of the sleeve?

In my twenties, I bought a lot of records at thrift stores, many just because of the covers: Martin Denny, Esquivel, Jimmy Smith, Claudine Longet, Bobby Brown.

Do you have a favorite album cover?

I really like Ed Ruscha's cover for Mason Williams' *Music* (1969). I also love finding altered sleeves at thrift stores and flea markets.

Are there album covers by an artist that changed the way you experienced the record? If so, why?

All sorts of packaging by Peter Saville. The music and the packaging together are much greater than the sum of their separate parts.

Are there records that you love the music but hate the sleeve or vise versa?

I don't hate any sleeves. Some are just boring. I'm happy to find enough that I think is not boring.

Are you drawn more to photography or paint on record covers?

It's all good.

INVADER

How old were you when you first noticed or fell in love with a record cover?

It is difficult for me to separate the record cover from the music. To me, it is a whole thing. I remember pretty well that one of the first albums I have bought mainly because of the cover was *Breakfast in America* by Supertramp. I think I was about 11 or 12 years old. After that, I started to listen to heavy metal because that was trendy at school—tough guys were wearing AC/DC pins! So I started to buy some albums like *Highway to Hell* (AC/DC) and *Killers* (by Iron Maiden). It lasted one or two years, and then I discovered and fell in love with punk rock and new wave. I remember that the three first albums I bought about it were *Never Mind the Bollocks* (Sex Pistols), the Clash's first LP, and *Boys Don't Cry* (The Cure). From then on, I've never quit listening to this kind of music.

Do you still like that record?

Breakfast in America? Yes, I still listen to it sometimes. I think it is actually a pretty good album even if I'm still mainly listening to punk rock and new wave.

Do you have a favorite album cover?

Not one, but several. That is why I've done a series of artworks that I've called Low Fidelity, where I reproduce my best album covers with Rubik's cubes. I guess I've done at least fifty of them until now. Sometimes because of the sleeves, sometimes because of the music, sometimes because I like both.

Is there an album cover by an artist that changed the way you experienced the record? If so, which album and why?

No, not one particular. But what is sure is that buying an album and listening to it and checking closely the visual artwork at the same time is the best and the only way for me to discover an album. That's a global experiment—sound and vision working together.

Are there records that you love the music but hate the sleeve or vise versa?

Yes, I think that Lou Reed's solo career includes many albums which the sleeves could be much better.

Are you drawn to more to photography, graphic design, or paint on record covers?

I don't care about that. The important thing is the feeling of it.

Have you ever designed a record sleeve?

Yes, I've made two. One was a few years ago for LSD, a famous french punk rock band that I have been listening to since I was a teenager. The second one is for Julie Colere, another French punk rock band who are friends of mine. I've just finished it, and the album will be released in two weeks.

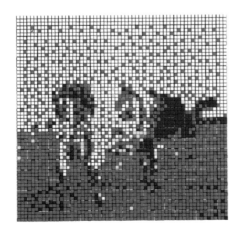
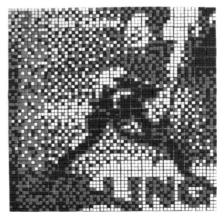
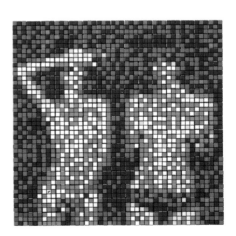

INVADER
There are now nearly four thousand INVADER
pixilated tile street works around the planet,
each individually numbered and with different
point values assigned to it. These have a rabid
following via his wonderful app, FlashInvaders.
However, fewer people know of his project,
RUBIKCUBISM [roo-bic-kyoo-biz-uhm] (noun),
where he recreates personal favorite sleeves
using Rubik's cubes.

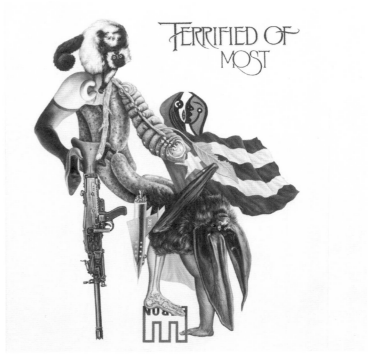

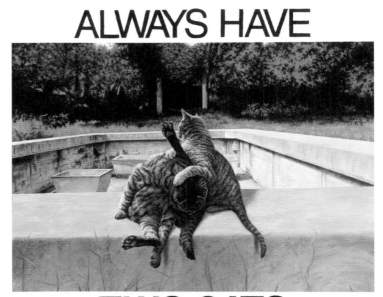

Eric White

Eric White's "LP" series feels like something out of a dream—indeed, a tribute to music and its lost forms. Most every piece is instantly recognizable, but on further inspection, the artist's humor and warped vision emerge.

Eric White

What is your earliest memory of a record sleeve, and how old were you when you first noticed or fell in love with a record cover? Do you still like that record?

I have a distinct memory of being with my mom at Liberty Music Shop in Ann Arbor when she bought *The Beatles*. I can still picture her pulling it out of the racks. It was not new at the time—it came out a few months after I was born in 1968—but I must have been around four when she got it. We, of course, had *Sgt. Pepper's* already, and I spent a lot of time bugging out on that cover, so technically that may be the earliest memory. But it has since been superseded by "The White Album." My uncle, whom I absolutely adored, was really into the band, and that record in particular. He urged me to dig into it, and I did. I became obsessed and used to play it over and over again, often through headphones. *Revolution 9* really did a number on me. I have a vivid recollection of being hunched over the coffee table drawing in dim light, while my parents argued away upstairs. I've always felt that in some sense that record protected me through the chaos leading up to their eventual divorce. The Beatles' music occurred so visually to me—I could picture it so clearly in my mind and it invigorated my imagination. It goes without saying that they took album packaging to another level, making it such an integral part of the entire experience. I remember being struck by the concept of the all-white gatefold, with THE BEATLES subtly debossed on the front, and there was something really intriguing and confusing to me about it. Inside the sleeve, of course, was the photo collage poster and color photos of the boys. I wouldn't discover until years later that the two albums that I endlessly scrutinized and reveled in were designed by the British Pop art titans Peter Blake and Richard Hamilton, who I now idolize and who opened the doors through which the American artists followed. I still consider "The White Album" my favorite album of all time, and it may just be my favorite cover as well—bold and radical and so sublime.

When I was young, I actually bought records simply because of how cool the sleeve looked to me. Did you ever buy a record simply because of the sleeve?

I've definitely done that. The cover of 10cc's *How Dare You!* by Hipgnosis is brilliant and hilarious and one of the greatest of all time. I owned it on vinyl for many years before ever listening to it. Another is *What Would the Community Think* by Cat Power. I did like the cover enough to buy it sight unseen, but admittedly the band name was a contributing factor as well.

Are there any album covers by an artist that changed the way you experienced the record? If so, which albums and why?

Houses Of The Holy comes to mind. Another iconic Hipgnosis masterpiece, one of my all-time favorites, and one I reinterpreted for my series of LP paintings. When I was young, I was terrified of Led Zeppelin. I think maybe I assumed they were satanic or something. In high school, I was in love with a girl, but I was insanely shy and introverted and had no idea how to approach her. I think word had spread that I had a crush on her, and I think she was into my drawings, so one day after school she invited me to her friend's place. We sat around and she played that record and I probably didn't say a word the entire time. But the music really hit me, and I realized the band was nothing like I had imagined. I had recently bought a CD player, before my parents or any of my friends owned one.

One of the very first things I got was *Houses*, of course with her in mind. I can still remember buying it at some depressing flea market, bringing it home, and playing it on my system in my room for the first time. It was only the third or fourth time I had ever smoked weed, and I put it on and stared at that cover forever. And *No Quarter* freaked me the hell out. Today it's my favorite Zeppelin record, and I can't hear anything from it without picturing that image. The orange sky and naked albino children crawling around an alien landscape are so otherworldly and bizarre. The cover is almost like a portal into the music for me.

When asked to create art for a sleeve by a musician, do you have to hear the music? Or what is the normal process?

For previous album cover gigs I would always request to hear the music prior to starting work, and in most cases labels would oblige. When Tyler got in touch I hadn't done an album cover in over 10 years and wasn't doing commercial work of any kind. I made an exception because I love him and love his music, but he's one of a handful of artists that I would even consider doing work for at this point. It was an honor to work with him and a really exciting project. I wanted to hear the music first, but I got the impression he was keeping it top secret, and I don't think he was even finished when it was time to start the painting, so I didn't push it. In this particular case I don't think hearing it would have altered the image much at all.

Are there records that you love the music but hate the sleeve or vise versa?

Double Thriller by The Glands has one of my favorite recent covers—a ghoulish looking dude at the beach in a winter jacket. For a re-release, they changed it to a withered hand on a sort of tablecloth pattern, and it's hideous. I love the Yes record *90215*, but I think the cover is an atrocity. They should have stuck with Roger Dean!

Is that what your LP pairings are about?

Eric White's "LP" series feels like something out of a dream—indeed, a tribute to music and its lost forms. Most every piece is instantly recognizable but on further inspection the artist's humor and warped vision emerge. The "Pink Flag" from Wire's 1977 art-punk classic is rendered as big as a bed sheet, "Too Much Content." For Fleetwood Mac's *Rumors* a disparate collection of imagery reminds us that in our hearts we are all "Terrified of Most." And White works one of his basic philosophies for a happy life into Frank Zappa's *Hot Rats*, with "Always Have Two Cats."

Alex Da Corte

What is your earliest memory of a record sleeve?

I remember the Disneyland Record's *Snow White and the Seven Dwarfs (Music From The Original Motion Picture Soundtrack)* from 1968. I would play it endlessly and walk in circles around my carpet singing "Heigh-Ho" with my brother.

How old were you when you first noticed or fell in love with a record cover?

I remember being in love with Al Green on the cover of *I'm Still In Love With You* (1972). My parents had that and Barry White's *Can't Get Enough* (1974) because "their song" *You're the First, the Last, My Everything* was on it. I liked both albums, but I loved the cover of Al Green's the most. He looked happy and cool in his monochrome, and I would imagine playing Nintendo with him.

Do you still like that record?

I am still in love with it.

When I was young, I actually bought albums simply because of how cool the sleeve looked to me. Did you ever buy a record simply because of the sleeve?

Absolutely. I remember buying Ween's *Chocolate and Cheese* before I knew what they sounded like. I was too young, but the cover was exciting to me. They ended up becoming one of my favorite bands.

Do you have a few favorite album covers?

Aretha Franklin's *Young, Gifted and Black* (1972), Janet Jackson's *Velvet Rope* (1997), Yaz's *Upstairs at Eric's* (1982), Dolly Parton's *Heartbreaker* (1978), Fiona Apple's *Tidal* (1996), Cat Power's *Moon Pix* (1998), The Breeders' *Pod* (1990), Paul McCartney's *RAM* (1971), TLC's *Oooooooohhh...On The TLC Tip* (1992), Antony & the Johnsons' *I Am A Bird Now* (2005), St. Vincent's *Actor* (2009), and Blood Orange's *Coastal Grooves* (2011), just to name a few.

Are there any album covers by artists that changed the way you experienced the record? If so, which albums and why?

I loved Vaughan Oliver's, Hipgnosis', and Peter Saville's album covers because they always lured me in. They were often opaque and didn't propose the music contained within the object was anything in particular or, at their best, were portraits of music, which was completely limitless and up for interpretation.

Is there an album you've always thought the sleeve doesn't fit the record? Or you wish you could make a new sleeve for it?

One of my all-time favorite albums is Fleetwood Mac's *Tusk*. I think, in comparison to the *Mirage* or *Rumours* album covers, it isn't my favorite cover. I would never want to change it, but if one were to judge an album by its cover, there is a chance one might miss the fucking masterpiece waiting beyond that little picture of Scooter the dog and a foot.

Are there records that you love the music but hate the sleeve or vise versa?

David Bowie's *Hours*.

Are you drawn to more photography or paint on record covers?

I never know what I like until I see it, and even then, I am not really sure.

Marilyn Minter

What is your earliest memory of a record sleeve?

My parents had a bunch of records, like Judy Garland records. I remember those.

How old were you when you first noticed or fell in love with a record cover?

The Freewheelin Bob Dylan was the first record I ever bought. I loved Bob Dylan, and I had never left the South at that point, so New York City looked so glamorous.

When I was young, I actually bought records simply because of how cool the sleeve looked to me. Did you ever buy a record simply because of the sleeve?

I bought The Roots CD for that reason without having listened to it. I also bought a few really bad punk albums because I liked the way they looked, but I threw them out because they were terrible.

Do you have a favorite album cover?

The Warhol banana one for The Velvet Underground.

Is there an album you've always thought the sleeve doesn't fit the record?

I don't know what doesn't fit, but Suicide's self-titled album from 1977 totally fits the music.

David Breskin
Thirteen ways of looking at album art

I

Music is the only invisible art form. From this restrictive quiddity comes opportunity's ripe abundance.

II

Goethe: "Music is liquid architecture; Architecture is frozen music." Music is spatial and temporal. Durational. It reveals section, plan, fragment, sequence, elevation, structure. But unlike architecture, music slyly covers its tracks—a polished criminal slipping the cops in the dark of night.

III

Music's a sharp icicle that stabs you right through the heart (cause of death, determined) only to melt and evaporate upon the sunny inquiring gaze of someone who wants to know how you're feeling, and why? Keep the thin edge of the wedge frozen: album art as puncture wound, as jagged tear, against the monotony of the banal, everyday dull march.

IV

A person who hears music but does not imagine images—shapes and forms, landscapes and colors, faces and bodies—as surely as he or she feels feelings, lives like a blind man in a deaf world.

V

A tortoise, wrapped neatly in a shell, venturing into the world. Walk, dig, mate, breathe, dig again...sometimes for decades.

VI

Start with the music. End with the music. Eyes closed for the perfect aspect ratio. No preconceptions. No conceptions. No concepts. To paraphrase Proust: A work of art with the concept still in it is like a gift with the price tag still on it.

VII

Make it what it wants to be. Make the punishment fit the crime.

VIII

A pre-determined aesthetic is death. (For every rule an exception: Reid Miles' Blue Note covers from '55 to '67.) But fifty years of ECM proves the point, ad nauseam.

IX

Shoulds! The outside should feel like the inside. The font should be chosen with promiscuous but strict care. The art should function as seduction, not advertisement. After multiple spins, the album should feel inseparable from its imagery. You wouldn't rip a baby from its mom, would you? You shouldn't.

X

1 + 1 = 2 is fact. 1 + 1 = 3 is art. 1 + 1 = 5 is sweaty, funky, magic act.

XI

An act of remembering, of remembrance. Always.

XII

An automatic worldwide assembly line of images produced by unseen *collaborators*. An endless wine pairing for an endless meal of both the chef's best and worst creations. Exquisite corpse for four billion earbuds.

XIII

Eiko Ishioka. Gerhard Richter. Julian Charrière. Ed Ruscha. Katie Paterson. Ken Price. Lordy Rodriguez. Joel Sternfeld. Glenn Ligon. Simon Norfolk. Andrew Masullo. Jim Campbell. Mimi Chakarova. Spottswood Erving.

Johanna Jackson

What is your earliest memory of a record sleeve?

Little Feat's *Salin' Shoes*. Super formative of my aesthetic, if not my sexuality? There's something so realistic in the depiction of the cake, the absence of a piece of her defining her sweetness and personal enjoyment. The landscape, the snail, the tiny inconsequential band member. I don't remember a note of the music. *Let It Bleed* was/is also pretty beautiful and complicated looking. I guess cake was my raft to beauty back then.

Are there bands and their sleeves that you used to love, but don't anymore?

I pretty much hate The Rolling Stones now.

Is there an album you've always thought sleeve doesn't fit the record?

Oh, as for really sounding like the record cover, Arvo Pärt's *Für Alina* put out by Mississippi Records. I think that as a rule, Mississippi Records always catch the insides on the outsides.

Los Charapas de Oro [by Los Mirlos] looks exactly like it sounds to me—the people turning into plants. John Cooper Clarke's *Disguise In Love* sounds like it looks. Chick Corea's *The Leprechaun* does not look like it sounds.

Do you have a few favorite album covers?

Some other faves: Yoko Ono's *Season Of Glass*, Dragging An Ox Through Water's *The Tropics Of Phenomenon*, Jackie-O Motherfucker's *The Cryin' Sea*, Sun Ra's *Angels and Demons At Play*. Cecil Taylor's *One Too Many Salty Swift and Not Goodbye, Is Alright Alright*.

Are you drawn more to photography or paint on record covers?

I like painting and drawn record covers. I'm not so attracted by ego ideal, cute band people, though that's not a rule. For example, I love the ego ideals presented by The Roches in their self-titled record, and, as I dismiss it, suddenly there are a million just like that, pictures of people authentically fronting their sounds.

Ryan McGinley

What is your earliest memory of a record sleeve?

The Smiths album cover with Joe Dallesandro shirtless in purple and blue coloring. I think it was my first homoerotic memory. I grew up the youngest of 8 children, and some of my brothers and sisters were into Morrissey and The Smiths.

How old were you when you first noticed or fell in love with a record cover?

I was probably 5 years old when I discovered *Houses of the Holy* by Led Zeppelin. It just resonated because I was around the age of the kids climbing the rocks. Later in life, I learned it was Giant's Causeway in Northern Ireland, which meant more to me because that's where my family heritage starts.

Do you still like that record?

Yes, of course. Zeppelin's "Over the Hills and Far Away" still makes me nostalgic for my youth.

When I was young, I actually bought records simply because of how cool the sleeve looked to me. Did you ever buy a record simply because of the sleeve?

The way I discovered Jane's Addiction was because of the two nude women with their heads on fire on the *Nothing's Shocking* album cover. They became my favorite band throughout middle school. They were the reason I started experimenting with drugs.

Do you have a few favorite album covers?

I love all the albums with nude imagery. It's probably my main inspiration for creating art. All I ever wanted was to take photos that looked like album covers. A Tribe Called Quest *The Low End Theory* is cool. I like how it has an abstract nude model painted in bold DayGlo body paint. Also, The Red Hot Chili Peppers' *Abbey Road* (where they have the socks on their cocks). They are spoofing The Beatles, which felt punk and funny to me when I was a teenager.

Is there an album cover by an artist that changed the way you experienced the record? If so, which album and why?

The Beatles' *Sgt. Pepper's Lonely Hearts Club Band* changed the game for me. Staring at that album cover and listening to tracks like "With a Little Help From My Friends" and "She's Leaving Home." I was originally drawn to it by their cool marching band outfits and Marilyn Monroe. Then I learned about so many influential artists from that one album cover. People such as Lenny Bruce, Aubrey Beardsley, Marlene Dietrich, Aldous Huxley, William Burroughs, and Oscar Wilde. As a young artist, studying all their influences really opened up many doors of inspiration for me.

Are you drawn to more to photography, graphic design, or paint on record covers?

Definitely photography.

Genesis P-Orridge

What is your earliest memory of a record sleeve?

A 7-inch EP of Frank Sinatra that my father had. Recorded when he was young and could still sing properly. My favorite song was "Laura," which many years later we played to Ian Curtis during the time he was recording the *Closer* album with Joy Division. Ian loved Sinatra's phrasing too. The first record we bought by myself was "Come On" by the Rolling Stones—a 7-inch single that came in a simple, orange striped Decca Records paper sleeve.

How old were you when you first noticed or fell in love with a record cover?

The first album cover we were amazed by, influenced by to this day, was Hapshash and the Coloured Coat's *Featuring The Human Host and The Heavy Metal Kids*. It was the first-ever record pressed in colored vinyl. Up till then, we had no idea vinyl could be different colors. This came in cool red vinyl on Minit Records. The sleeve was by London-based psychedelic poster designers Nigel Waymouth and Michael English, getting on down with the Heavy Metal Kids, a.k.a. Art, a.k.a. Spooky Tooth. Rumor has it, John Peel and Steve Peregrin Took are in there somewhere, in this acid-drenched jam session. (Jimi Hendrix played on the Art album.)

Do you still like that record?

We still love this album. We DJ occasionally a set of heavy psychedelic music and garage pop in New York clubs and always play "H-O-P-P- Why?" which was dedicated to London counterculture legend John "Hoppy"

Hopkins, who had just received a several-year prison sentence for having a single joint of hashish.

When I was young, I actually bought records simply because of how cool the sleeve looked to me. Did you ever buy a record simply because of the sleeve?

Yes, that same Hapshash record.

Do you have a favorite album cover?

That same Hapshash album.

Is there an album cover by an artist that changed the way you experienced the record? If so, which album and why?

No, not really.

Have you made work for a sleeve based on the music from the artist? If so, can you describe that process a little?

I really enjoyed creating album covers for all the live Psychic TV records. But also I (alone) took all the original photos for the front and back of *D.o.A: The Third And Final Report of Throbbing Gristle*. The little girl was Kama Brandyk, daughter of my then lover Ewa. My original front cover design included an inset photo of Kama, who had pulled up her skirt to show her panties. She had asked her mother Ewa if she could pose like the pretty women in magazines. Ewa said yes. This inset on the front cover was fine when the record was released, but over the decades since it has become more and more, understandably, controversial as it is open to misinterpretation. At the time, I saw it as just as innocent and playful as it actually was when I took it. Sadly, the corrupt influence of the internet and spread of pedophilia has recontextualized it for some people. Mute Records recently re-released the album but with the inset of Kama removed from my front cover photo. Kama was listening to *Alice in Wonderland* in Polish on the radio when I took the main

front cover photo. My inset photos on the back cover are of Hackney, home of TG, Industrial Records, Psychic TV, and Thee Temple Ov Psychick Youth locations, plus one of Lodz, Poland government housing where Ewa and Kama lived.

Is there an album you've always thought the sleeve doesn't fit the record? Or you wish you could make a new sleeve for it?

No.

Are there records that you love the music but hate the sleeve or vise versa?

Not really. I tend to see record covers as an opportunity to express concepts and sociopolitical and occultural ideas. A place for propaganda. The backs of the Psychic TV live series, I treated as a publication. Like a magazine in multiple editions. Each back cover had an essay on how to short-circuit control or ways to reassess human behaviors that are negative or shamanic evolutionary strategies...content like that. Chapters of a book in a way. Eventually, the first-ever version of *Thee Psychick Bible* was published as an actual book by Joe A. Rapoza in San Francisco.

Why waste a 12-inch square of paper with bullshit just about band members, etc. when you can speak to thousands of fans and interested people instead? Hoping to literally CHANGE THEIR MINDS...?

Are you drawn more to photography or paint on record covers?

Whatever medium works to carry the ideas at that time.

Genieve Figgis

What is your earliest memory of a record sleeve?

The earliest memory of a record sleeve that blew me away was the *Hell Awaits* cover by Slayer. The artist was Albert Cuellar, and he had been inspired by a Jean Giraud comic illustration. It was released in 1985.

I would have only been 13 when *Hell Awaits* was released and not lucky enough to see them on tour until 1986 when the *Reign in Blood* album was released.

Hell Awaits appealed to my taste for the unknown. It depicted our moral shortcomings and confirmed everything of my religious education. The theatrical imagery was very interesting to me at the time and maybe had the shock factor. I had been a young reader of Edgar Allen Poe and

had not been introduced to much art until the late '80s.

The *Hell Awaits* album cover was a bit risqué at the time, yet it only put a vision of what was preached at school and at Sunday Mass. It introduced me to the idea of creating an image to fit a story. Depicting a vision and portraying our deepest fears and desires for the unknown. Artists that have also done this would still be favorites— Hieronymus Bosch, Goya, and Bruegel.

In my teenage years, I also enjoyed some of the early Iron Maiden covers. The Eddie Beast that was depicted on their covers was something that attracted me to paint. I painted my bedroom wall with the *Life After Death* cover, and friends and family were very generous and let me decorate their bedroom walls also.

David Ellis

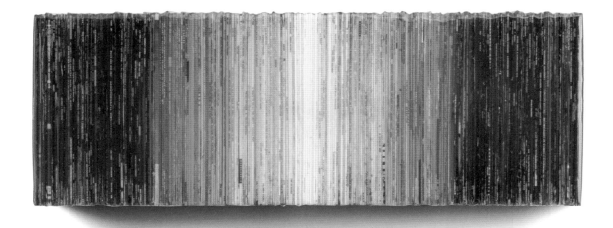

David Ellis
David Ellis' "Recollection" series of sculptures
are constructed from album covers, wood,
and resin. While at once nostalgic, they center
around beautiful and pristine gradients. Ellis
fossilizes the past, encasing the vintage record
album covers in a glossy layer of resin.

Carlo McCormick

For the Record: The Cover Story of LP Art

It was a bit of divine origami, the cut and folding of a piece of lowly cardboard to create a perfect square, a one-foot-by-one-foot sleeve to hold a then-novel new musical delivery system, the 12" long-playing record, or as it was known to industry, consumers, fans, and collectors alike, the LP. Conceived earlier but put on hold for World War II, the 33.3 revolutions per minute LP record was introduced in June of 1948.

Arriving as it did then, when the diminishment of material resources and restrictions of a wartime economy gave way to the potentials of a consumer economy boosted by a new prosperity, a massive Baby Boom in the population, a rising culture of leisure, and an inherent desire to replace the deprivations and horrors of the preceding Depression and World War with a populist ideal of comfort and normalcy, the LP signaled something utterly contemporary, something as modern as that prior geometry of the new, Malevich's Black Square. It would soon prove to be one of the greatest canvases for creative and cultural expression ever to hit the marketplace.

To be clear, the idea of the record cover, or the then-radical concept of putting art on it, was not devised by marketing strategists or, in fact,

even enjoyed much enthusiasm from the record industry. Be it a visual intuition, an aesthetic intervention, or a creative impulse, the task of designing the cover for this new audio delivery system and the vision to adorn this package with something more than generic clip art came from an artist named Alex Steinweiss. Steinweiss began his tenure at Columbia Records in 1938 as their first art director when few in America, or the rest of the world for that matter, had any notion of what an art direction was beyond the most menial of mechanical tasks.

Previously, records were 78 rpm discs that were sold in simple bags that might sport the logo of the store selling them, or collected in sets called albums that might be distinguished by little more than a music stand with the name of the symphony, orchestra, and composer on them. It was Steinweiss who, after numerous rejections and much perseverance, talked his bosses into letting him put some of his original art on a record that was being reissued with little hope of much success.

Consumers loved it, sales for it skyrocketed, and the way we looked at music was changed forever.

Alex Steinweiss not only introduced fine art to the record jacket, he in fact created it. When it proved that the new 33 rpm discs would get damaged in the bags used for 78s, Steinweiss not only figured out the cardboard sleeve, he found a manufacturer for it. He also held the copyright for the record cover, but because he was working for Columbia at the time, the record label figured it belonged to them.

Issues of authorship and ownership aside, the very nature of Steinweiss' creative contribution was such that it invited a half-century of prolific creativity across the world and put in place a potent synaesthesia whereby music and visuals will be forever interwoven within the public imagination.

Now, they are not only inseparable, but together their capacity to conjoin sight and sound produces a sensory dynamic that continues to impact visual artists and musicians alike.

Artists are always early adopters and ready adapters when it comes to any development in our visual language. Indeed as we try to understand the nature of record cover design and how it works, we need to read them. The filmmaker D. A. Pennebaker once told me that when he made *Monterey Pop* in 1967 (released in 1968), the first and arguably greatest rock concert documentary, it was looking at the record covers of the time that inspired him. That is, for someone older and not of that youth culture, he saw in the record covers a coded language that was not only telling kids where to go, how to dress, and what drugs to take but also doing so in a way that their parents couldn't even decipher. And all languages are themselves subject to constant change, evolving through usage, developing dominant and subcultural argots, broadcasting recognizable messages or inscribing discrete meanings, seeking an audience in which recognition signifies understanding.

As such, the long and broad arc of record cover art has operated at an interstice between the commercial needs of an industry and the desires of the artists.

In truth, if it were not for the popularity and pervasiveness of the LP record, we might never have known the tremendous artistic talents of those who found their voice through this medium. Pioneers of the medium—in particular, those who worked in the era when illustration ruled, that is before the mid-1950s when photography tended to dominate—created distinctive styles that at once seduced the listener while seemingly informing their appreciation of the music. Among the greats of this period were Jim

Flora, whose work for Columbia and RCA in the '40s and '50s remains some of the most idiosyncratic of commercial design, rife with exuberant play, radical distortion, and absurd violence; David Stone Martin, whose prolific body of work for labels like Mercury and Asch carried the deft linework and social politics of Ben Shahn that, in many ways, came to define artists like Billie Holiday and Woody Guthrie; and Reid Miles, who as art director for Blue Note Records created stunning compositions of odd-angle photography, simple monochrome filters, and wildly inventive typography that seemingly personified jazz. But, of course, as music changed, so too did those charged with its look.

In the decades that followed, there have been so many record covers that are so iconic, indelible, and influential in terms of our appreciation of music that to list them all would be impossible and perhaps too subjective, for our like or dislike of the music has a way of coloring our perceptions of the art. Amongst aficionados, however, there exists a pantheon of remarkable figures most agree upon. The era of psychedelic rock in the '60s offered up a number of monumental masterworks from the likes of Stanley Mouse, along with his latter collaborator Alton Kelley, the inimitable Rick Griffin, who, like Mouse, is best remembered for his work with The Grateful Dead; and of course Mati Klarwein, whose visionary paintings were adopted as record covers by the likes of Santana and Miles Davis.

Special honors are due as well to the important British pop artists: Peter Blake, for his landmark *Sgt. Pepper's* Beatles album and Richard Hamilton for the minimalist triumph of his cover for the Beatles, "White Album."

In the pomp and circumstance of '70s arena rock, few could forget the fantasy paintings Roger Dean did for Yes or the work of

Hipgnosis studios for bands like Pink Floyd and Led Zeppelin (and its founder Storm Thorgerson's subsequent career working for so many other musicians). In a more classic mode, David Berg achieved lasting recognition with the covers he produced for The Byrds, Bob Dylan, Simon and Garfunkel, and Bruce Springsteen. Most would also have to cite Cal Schenkel for his work with Captain Beefheart, along with many others. And if there ever was a visual maestro for funk, it was certainly Pedro Bell, with his fantastical covers for Parliament Funkadelic.

Punk, which beginning in the '70s released a radically creative DIY sensibility across all manner of creative practice, produced several seminal artists including Jamie Reid, whose cut-and-paste ransom-note graphics for the Sex Pistols epitomized Situationist intervention; Arturo Vega, who branded The Ramones into visual icons; Gee Vaucher, whose hardcore politics matched perfectly that of Crass, the band she worked with; as well as Winston Smith, whose deviant collages of the false American Dream became emblematic for the Dead Kennedys. In the wake of punk, in the era we might call, for lack of a better term, post-punk—and also quite possibly the end of the vinyl era before it was economically dismantled by the visually less compelling formats of audio tapes and compact discs and, eventually, the full dematerialization of the product through MP3 file sharing and streaming services—as well put forward many significant designers inextricably linked with independent labels such as Peter Saville at Factory Records, Barney Bubbles at Stiff Records, and Vaughan Oliver at 4AD. In postscript to this severely abbreviated history, it is worth mentioning that the next truly inventive and musically dominant movement, hip hop, would rely on photography, fashion, and styling more than purely visual

artists, but is notable for involving a number of significant graffiti artists in its graphic design, including but not limited to Futura, Haze, and Cey Adams.

This then is the barest detailed map of the highlights and landmarks along the winding road of LP record art, a backward glance to better understand the recent and somewhat more esoteric directions this once-dominant populist medium has taken that are charted in this book. Perhaps recorded music might not mean nearly so much to many of us without these artists, and, just as likely, many of these artists might not mean so much to us without their contributions to this genre and medium. But the synaesthesia, that confusion of the senses, between art and music has long mattered as much to musicians as it has to visual artists, and it is worth keeping in mind that these kinds of collaborations have involved some of today's most celebrated fine artists including Banksy, Jean-Michel Basquiat, Salvador Dalí, Shepard Fairey, H. R. Giger, Keith Haring, Damien Hirst, Mike Kelley, Jeff Koons, Robert Mapplethorpe, Ryan McGinley, Richard Prince, Robert Rauschenberg, Gerhard Richter, Fred Tomaselli, and Andy Warhol. So even if you don't have a turntable, take the time to look at records for the art form they truly are—it will be visual music to your ears.

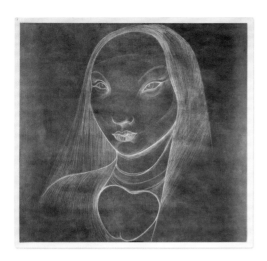

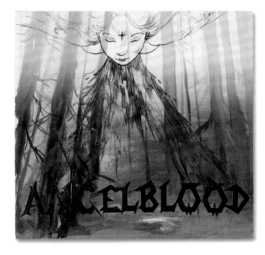

RITA ACKERMANN
music: Rita Ackermann
title: Ga'zheart
LP, single-sided etched
US. 2008. Edition size unknown

RITA ACKERMANN
music: Angelblood
title: Angelblood
CD
Japan. 2000

RITA ACKERMANN
music: Rita Ackermann
title: When Sunny Expands
LP, single-sided etched red vinyl
US. 1997. Edition of 100

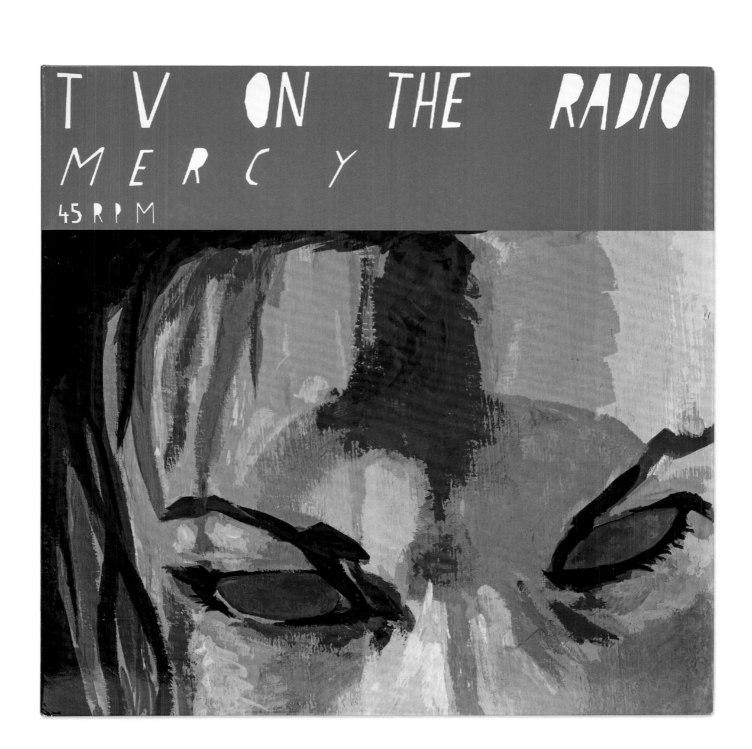

TUNDE ADEBIMPE
music: TV On The Radio
title: Mercy
12"
US. 2013

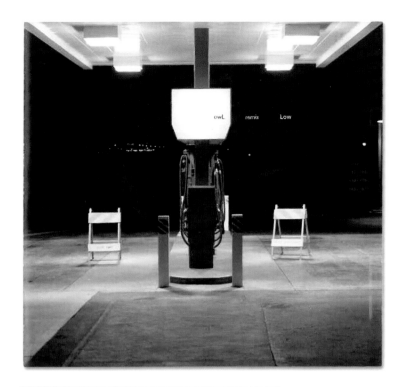

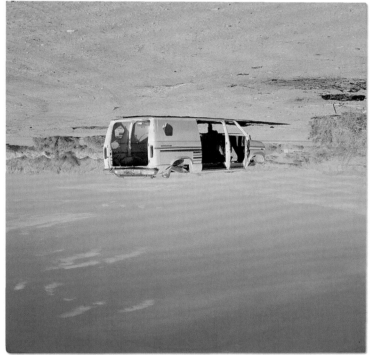

DOUG AITKEN
music: Low
title: Owl Remix
12"
US. 1998

DOUG AITKEN
music: David Grubbs
title: Act Five, Scene One
CD
US. 2002

LISA ALVARADO
music: Joshua Abrams
title: Magnetoception
2 × LP
US. 2015. Edition of 875

LISA ALVARADO
music: Joshua Abrams & Natural Information Society
title: Simultonality
LP
US. 2017. Edition of 825

LISA ALVARADO
music: Joshua Abrams
title: Represencing
LP
US. 2012. Edition of 550

LISA ALVARADO
music: Joshua Abrams & Natural Information Society
title: Mandatory Reality
2 × LP
US. 2019. Edition of 999

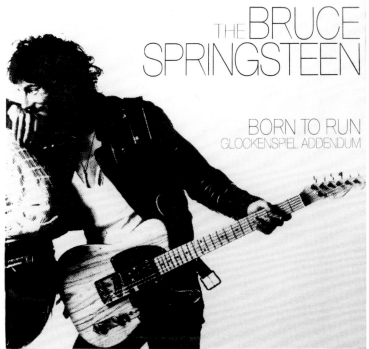

ED ATKINS / THE VINYL FACTORY
music: Ed Atkins
title: Ribbons
12" LP, white vinyl
UK. 2014

CORY ARCANGEL
music: Cory Arcangel
title: The Bruce Springsteen Born To Run Glockenspiel Addendum, 2006
12"
US. 2007. Edition of 300

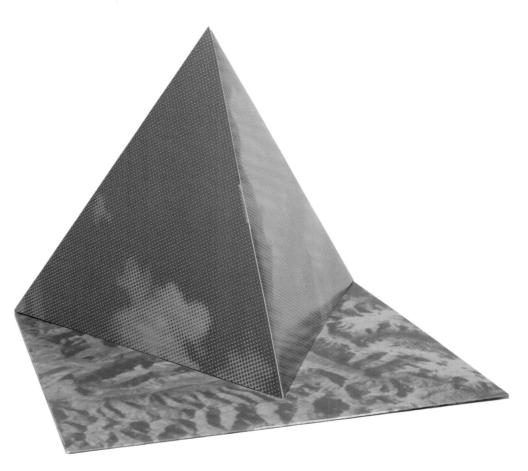

TAUBA AUERBACH
music: The Alps
title: Easy Action
LP (front + back cover + folded out die cut)
US. 2017. Edition of 1,000

SACRED BONES
RECORDS

SBR-033

EFFI BRIEST

an LP recorded in 2009

Rhizomes

SIDE A: Rhizomes; Long Shadow; Cousins; New Quicksand; X
SIDE B: Mirror Rim; Nights; Wodwoman; Shards

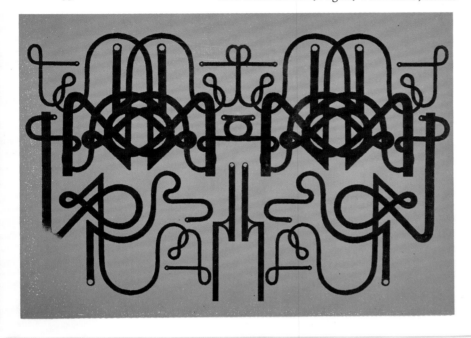

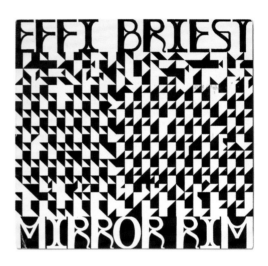

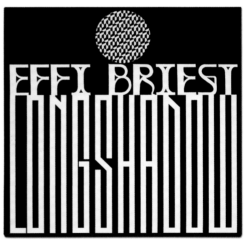

TAUBA AUERBACH
music: Effi Briest
title: Rhizomes
LP
US. 2010

TAUBA AUERBACH
music: Effi Briest
title: Mirror Rim
7"
UK. 2007

TAUBA AUERBACH
music: Effi Briest
title: Long Shadow
7"
UK. 2008

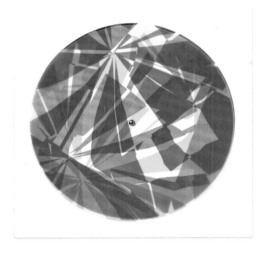

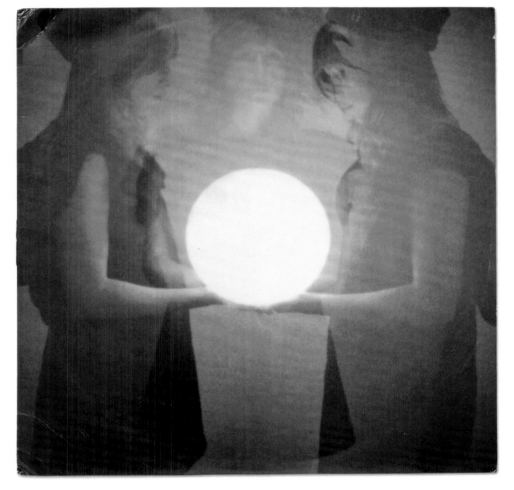

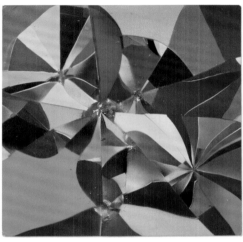

TAUBA AUERBACH
music: Glasser
title: Apply
12"
US. 2009. Edition of 500

TAUBA AUERBACH
music: Glasser
title: Tremel
12"
UK. 2010

TAUBA AUERBACH
music: Glasser
title: Ring
LP
US. 2010

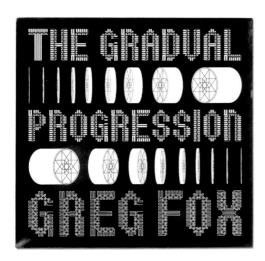

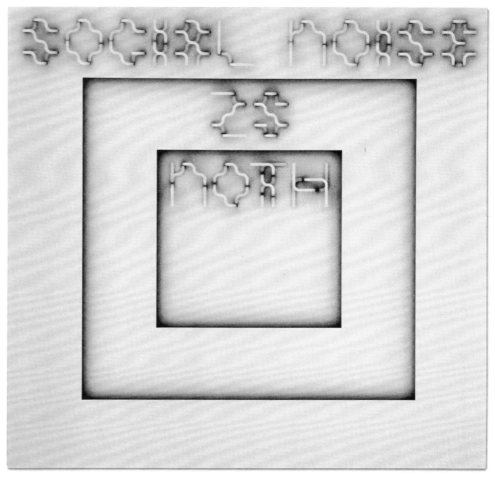

TAUBA AUERBACH
music: Greg Fox
title: The Gradual Progression
LP
US. 2017. Edition of 100

TAUBA AUERBACH
music: Drew McDowall & Hiro Kone
title: The Ghost Of Georges Bataille
12"
US. 2018

TAUBA AUERBACH
music: Zs
title: Noth
LP
US. 2018

JOHN BALDESSARI
music: Andrew Bird
title: Are You Serious
LP box set includes blue LP + yellow 10" + red 7" (interior images)
UK / Europe. 2016. Edition of 1,000

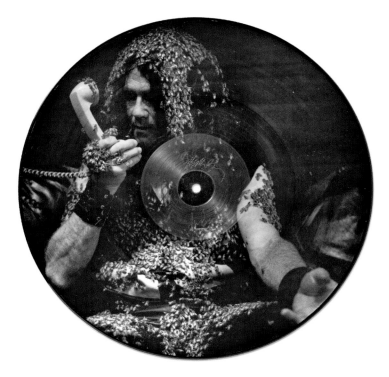

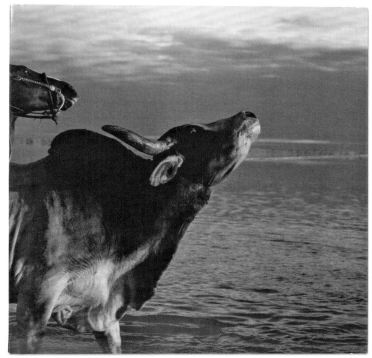

MATTHEW BARNEY
music: Bepler
title: The Man In Black / Drone Harness
12" + picture disc (front cover + picture disc)
US. 2000. Edition of 500

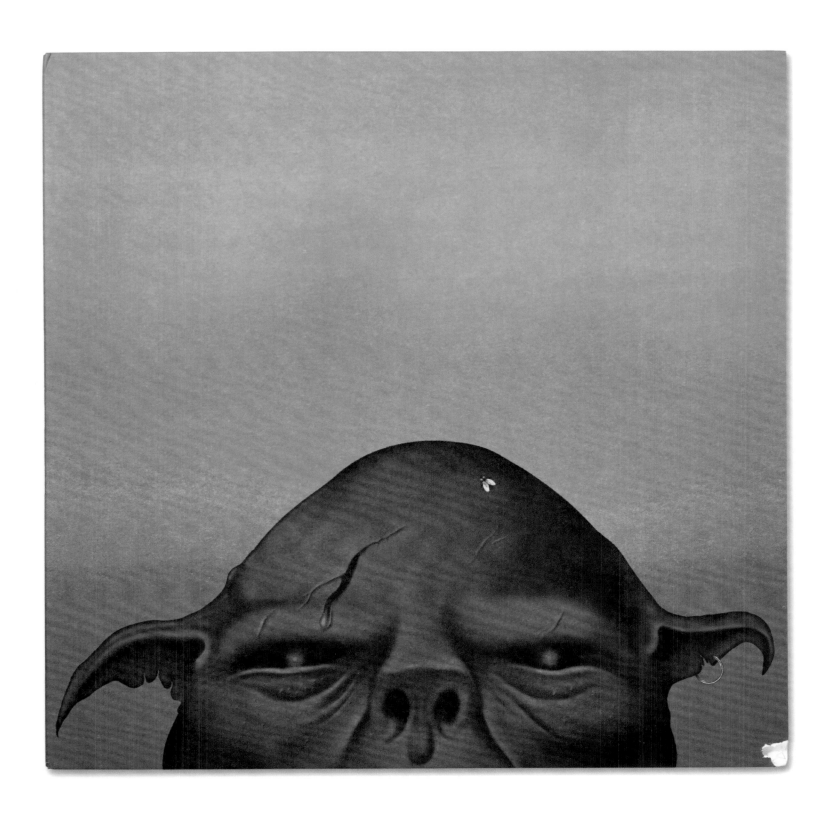

ROBERT BEATTY
music: Oh Sees
title: Orc
2 × LP
UK. 2017. Edition of 1,000

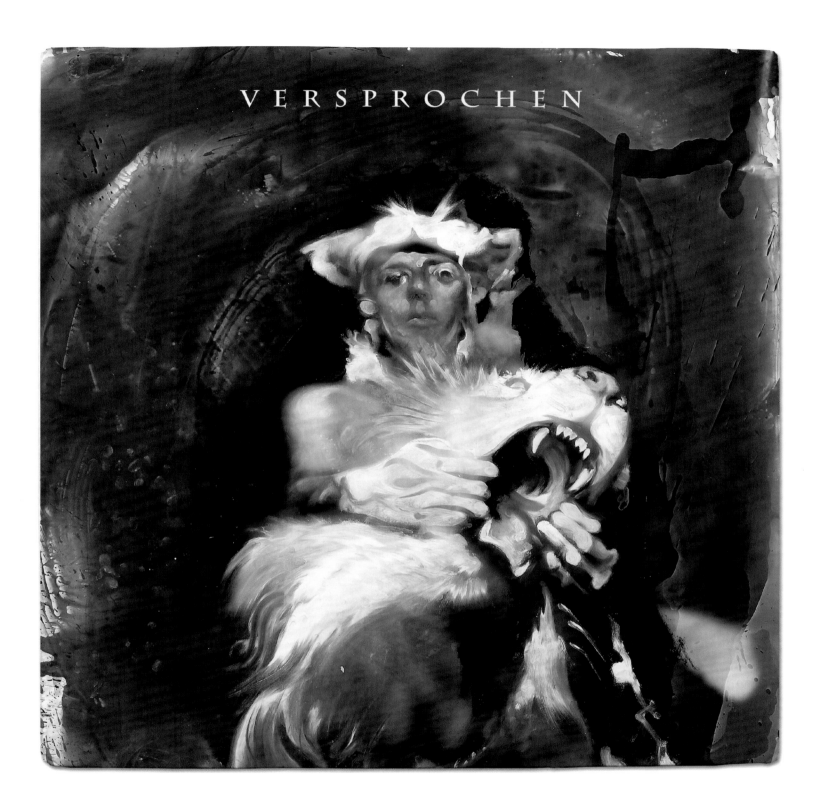

DIRK BELL
music: Konrad Sprenger
title: Versprochen
LP
Italy. 2009. Edition of 300

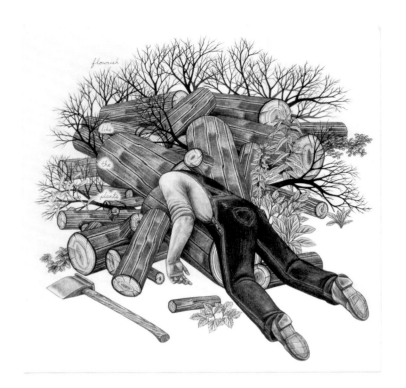

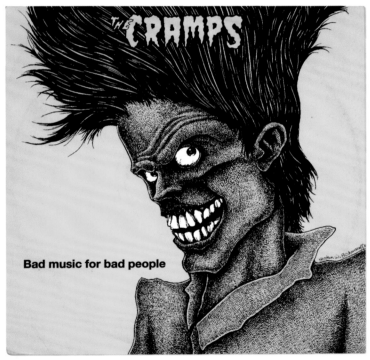

ERIC BELTZ
music: Hunters, Run!
title: EP 2
7"
US. 2009

STEPHEN BLICKENSTAFF
music: The Cramps
title: Bad Music For Bad People
LP compilation
US. 1984

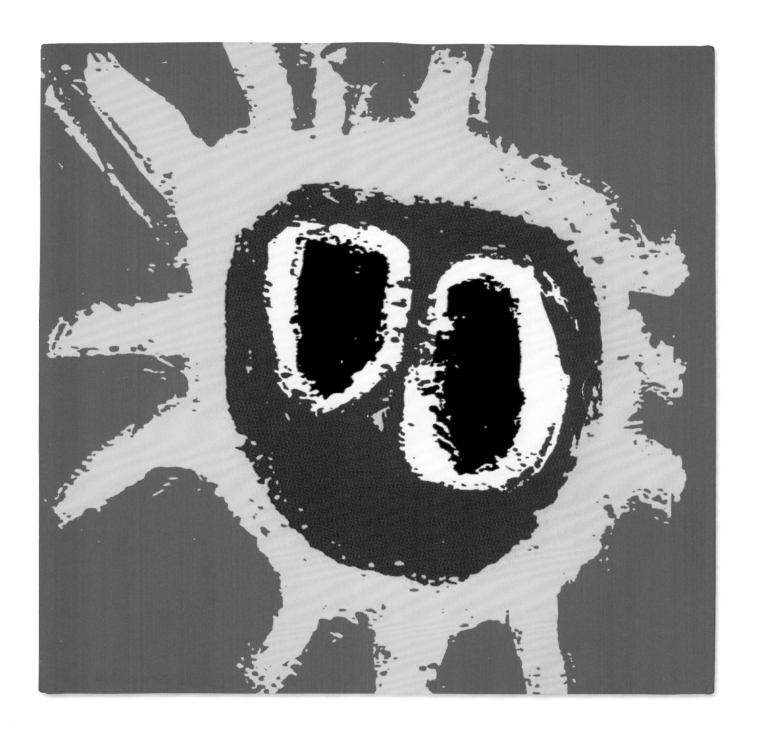

PAUL CANNELL
music: Primal Scream
title: Screamadelica
2 × LP
UK. 1991

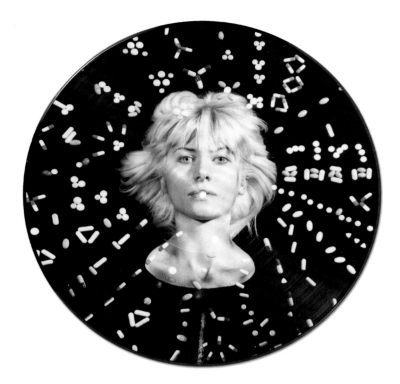

MAURIZIO CATTELAN / THE VINYL FACTORY
music: Maurizio Cattelan
title: I Always Remember a Face, Especially When I've Sat on It
LP compilation picture disc
UK. 2013. Edition of 1,000

MAURIZIO CATTELAN / THE VINYL FACTORY
music: Toilet Paper x Daft Punk
title: Da Funk / Teachers
12" picture disc
UK. 2016. Edition of 1,000

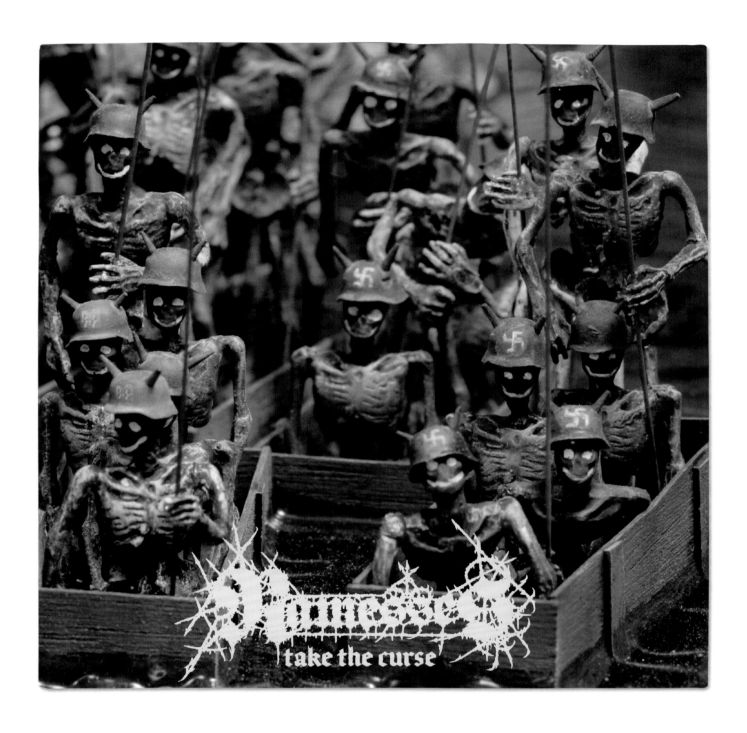

JAKE & DINOS CHAPMAN
music: Ramesses
title: Take the Curse
2 × LP + 7" reissue
UK. 2012

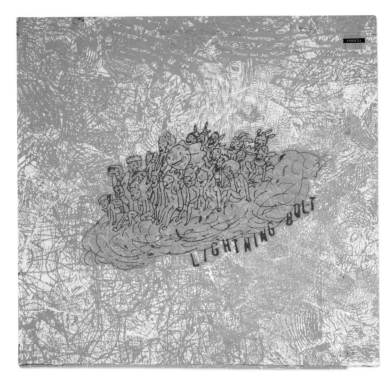

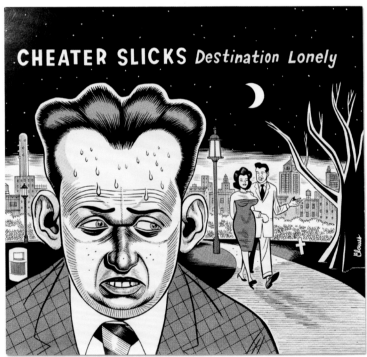

BRIAN CHIPPENDALE
music: Lightning Bolt
title: Ride The Skies
LP, fold-out screen-printed sleeve
US. 2001. Edition of 1,000

DANIEL CLOWES
music: Cheater Slicks
title: Destination Lonely
LP
Australia / US. 1991 / 2017

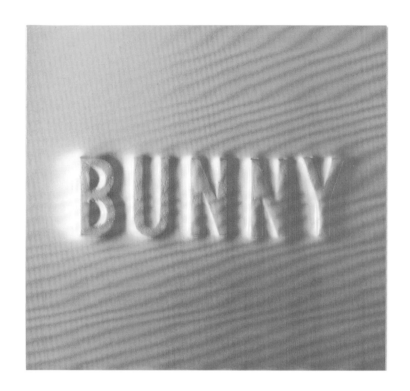

MICHAEL CINA
music: Matthew Dear
title: Bunny
2 × LP, rainbow-splatter vinyl
US / Europe. 2018. Edition of 1,000

JASE COOP
music: Loraine James
title: For You And I
LP
UK. 2019

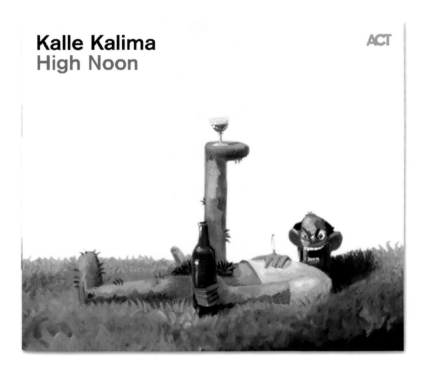

GEORGE CONDO
music: Kalle Kalima
title: High Noon
CD
Germany. 2016

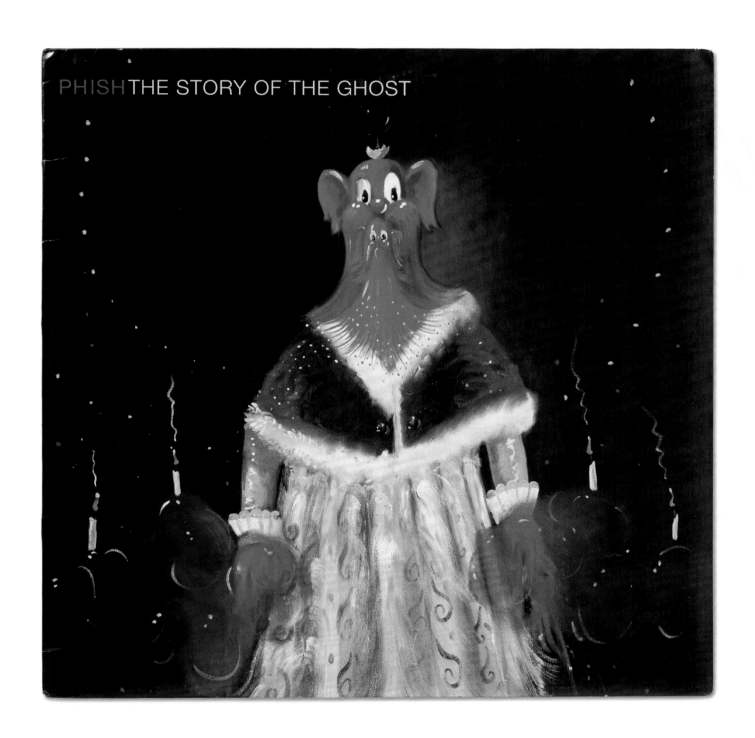

GEORGE CONDO
music: Phish
title: The Story Of The Ghost
LP
US. 1998

BJORN COPELAND / SEEN STUDIO
music: Black Dice
title: Black Dice
7"
US. 1998

BJORN COPELAND / SEEN STUDIO
music: Black Dice
title: Creature Comforts
LP
US. 2004

BJORN COPELAND / SEEN STUDIO
music: Wolf Eyes & Black Dice
title: Wolf Eyes & Black Dice
LP
US. 2003

BJORN COPELAND
music: Paradis
title: Parfait Tirage b/w La Ballade De Jim
12"
US. 2011

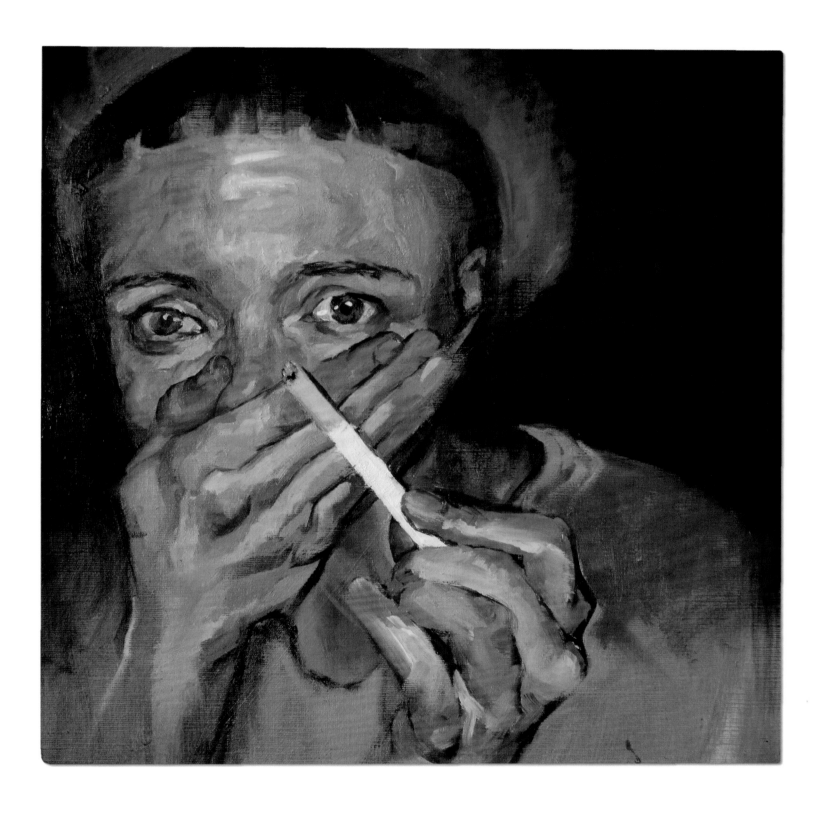

STU CRANFIELD
music: Giant Swan
title: Giant Swan
LP
UK. 2019

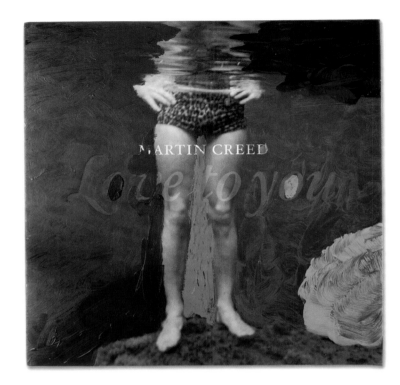

MARTIN CREED / THE VINYL FACTORY
music: Martin Creed
title: Love To You
LP, transparent vinyl
UK / Europe. 2012.
Edition of 150 hand painted + signed + hand numbered

MARTIN CREED
music: Martin Creed
title: Martin Creed
CD
UK. 1993. Edition size unknown

MARTIN CREED / THE VINYL FACTORY
music: Martin Creed
title: Chicago (Work # 1370)
12"
UK. 2012. Edition of 200 signed + signed + hand numbered

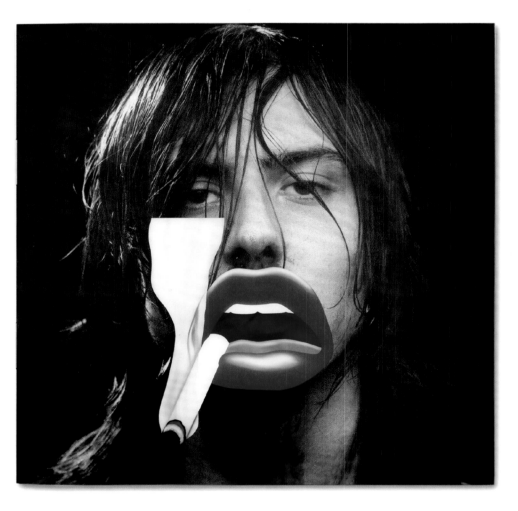

ALEX DA CORTE
music: Søren Kjærgaard
title: Weaver
12"
Denmark. 2016. Edition of 350

ALEX DA CORTE
music: Spank Rock
title: Energy
12"
Germany. 2011

ALEX DA CORTE
music: Andrew W.K.
title: C-A-T Spells Murder Special Edition
CD + hardcover book
US. 2018. Edition of 100

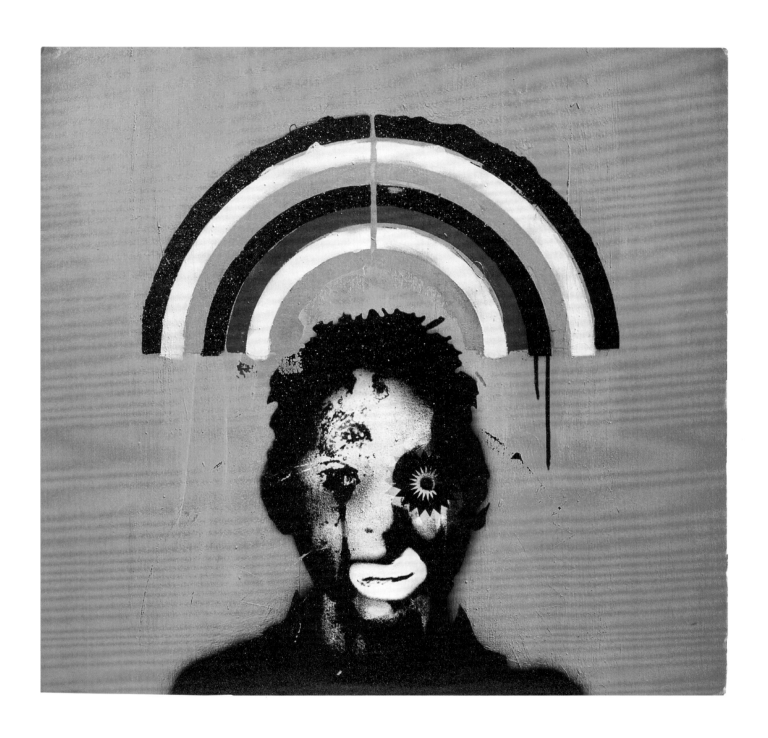

ROBERT DEL NAJA / THE VINYL FACTORY
music: Massive Attack
title: Heligoland
2 × LP + 12" + CD + booklet
UK. 2010

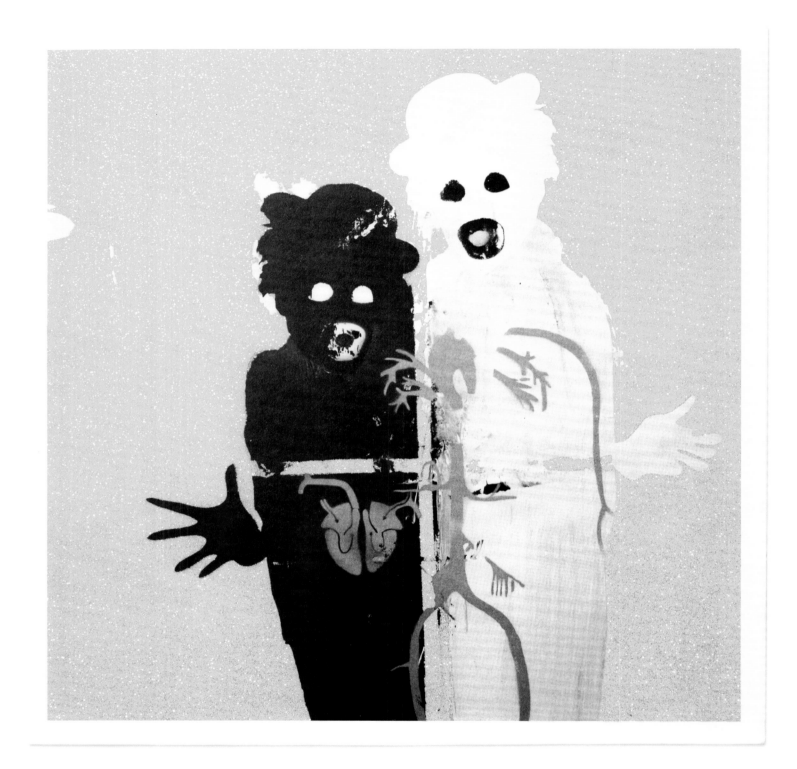

ROBERT DEL NAJA / THE VINYL FACTORY
music: Massive Attack
title: Atlas Air EP
12"
UK. 2011. Edition of 1,000 stamped + numbered on screen-printed glitter sleeve

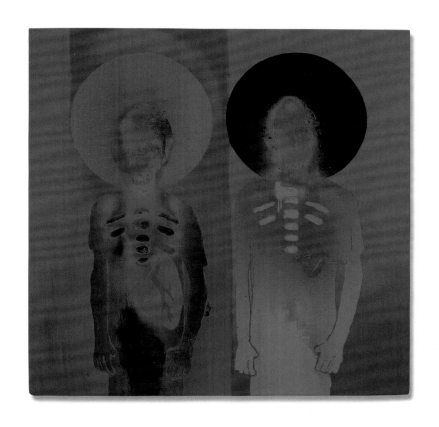

ROBERT DEL NAJA
music: UNKLE
title: War Stories
4 × LP box set + 50-page book of art
UK. 2007. Edition of 2,000

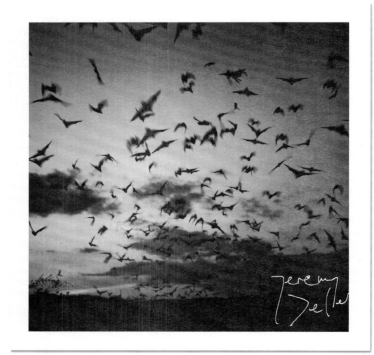

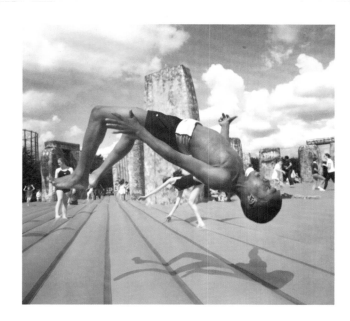

Jeremy Deller, English Magic, 2013.

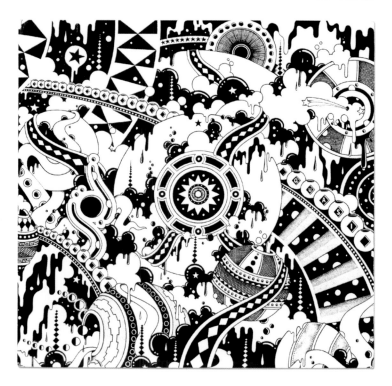

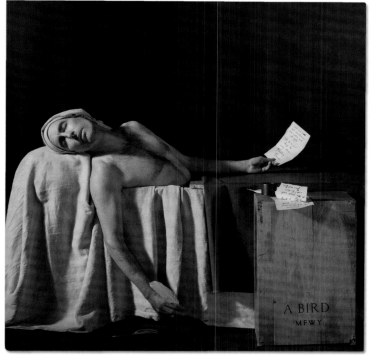

JEREMY DELLER
music: Jeremy Deller
title: Exodus
12"
UK. 2012. Edition of 50 signed + numbered

AINDRIAIS DOLAN
music: Quasi
title: Mole City
2 × LP
US. 2013

JEREMY DELLER
music: Jeremy Deller And The Melodians Steel Orchestra
title: English Magic
12"
UK. 2013

AMANDA DEMME
music: Andrew Bird
title: My Finest Work Yet
LP
US. 2019

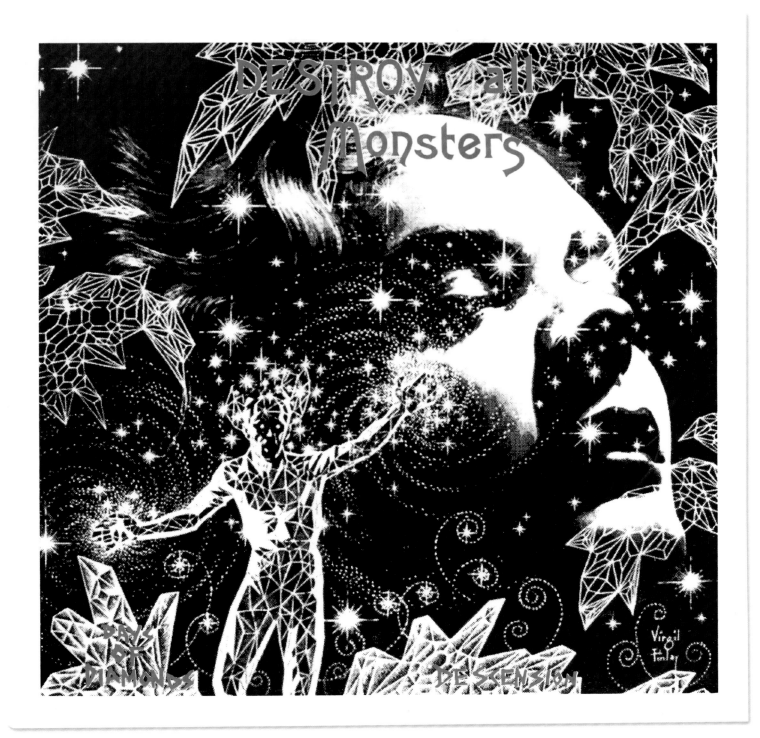

DESTROY ALL MONSTERS
music: Destroy All Monsters / Xanadu
title: The Black Hole
LP, purple vinyl + silk-screened cover
US. 2017. Edition of 1,000

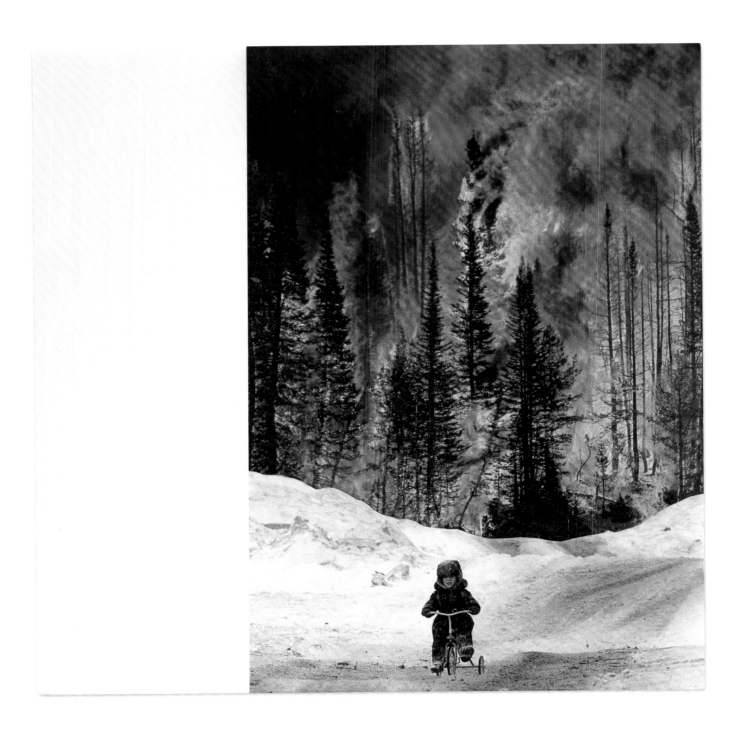

CALI THORNHILL DEWITT
music: Nick Dewitt
title: Untitled
LP
US. 2012

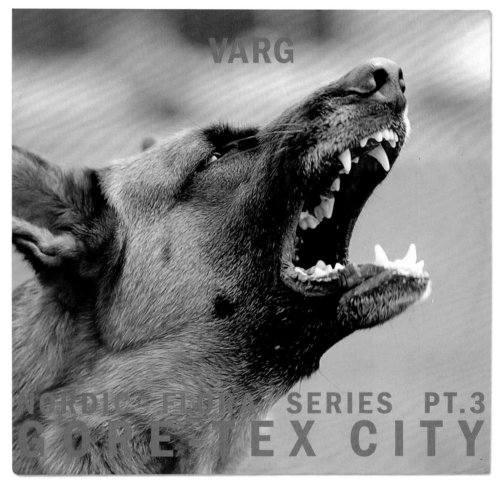

CALI THORNHILL DEWITT
music: Hoax
title: Hoax
LP
US. 2013

CALI THORNHILL DEWITT
music: John Wiese
title: GGA
LP, clear vinyl
US. 2011. Edition of 330

CALI THORNHILL DEWITT
music: Varg
title: Nordic Flora Series Pt. 3, Gore-Tex City
2 × LP, transparent red vinyl
Sweden. 2017

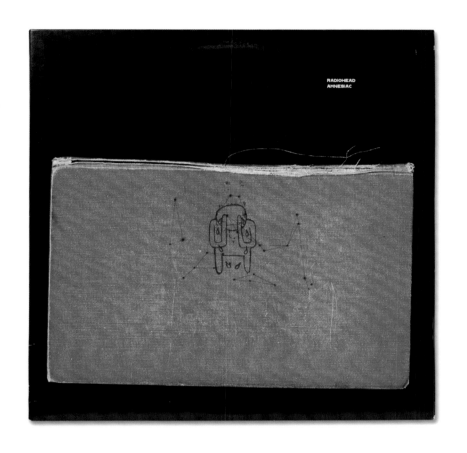

STANLEY DONWOOD
music: Radiohead
title: Amnesiac
2 × 10" LP
Europe. 2001

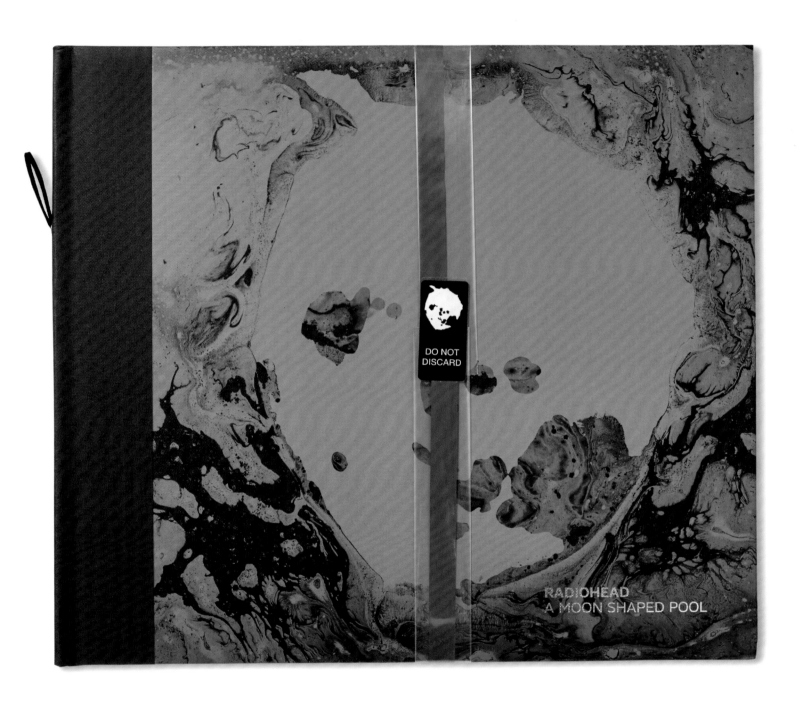

DO NOT
DISCARD

RADIOHEAD
A MOON SHAPED POOL

STANLEY DONWOOD
music: Radiohead
title: A Moon Shaped Pool
2 × LP + CD + 32-page booklet + box, bound in half-inch recording tape
UK / Europe / US. 2016. Edition size uknown

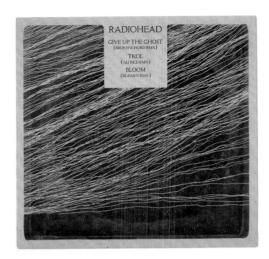

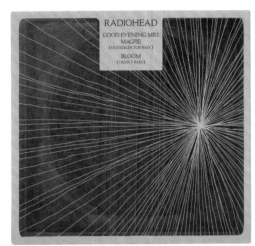

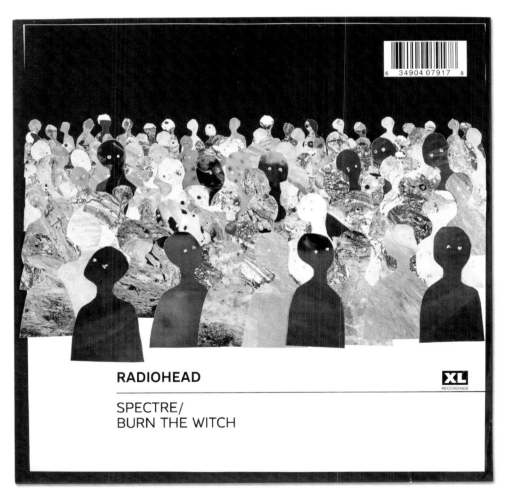

STANLEY DONWOOD
music: Radiohead
title: Give Up The Ghost (Thriller Houseghost RMX) /
Codex (Illum Sphere RMX) / Little By Little (Shed RMX)
12"
UK. 2011. Edition size uknown

STANLEY DONWOOD
music: Radiohead
title: Give Up The Ghost (Thriller Houseghost RMX) /
Codex (Illum Sphere RMX) / Little By Little (Shed RMX)
12"
UK. 2011. Edition size uknown

STANLEY DONWOOD
music: Radiohead
title: Burn The Witch / Spectre
7"
UK / US. 2016. Edition size unknown

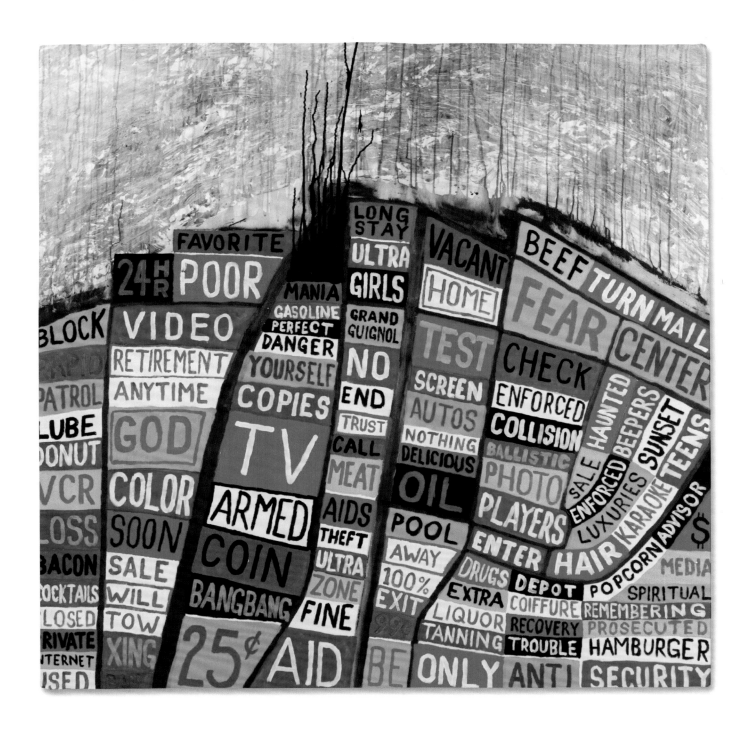

STANLEY DONWOOD
music: Radiohead
title: Hail To The Thief
2 × 12"
Europe. 2003

61

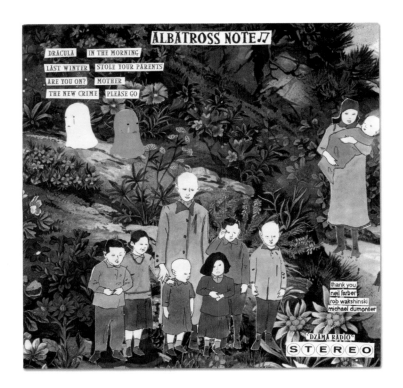

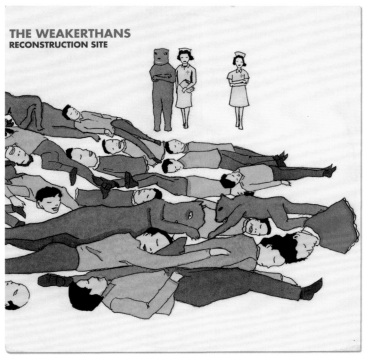

MARCEL DZAMA
music: Albatross Note
title: The Dracula EP
9", green marbled vinyl
US. 2005

MARCEL DZAMA
music: The Weakerthans
title: Reconstruction Site
LP
US / Canada. 2003

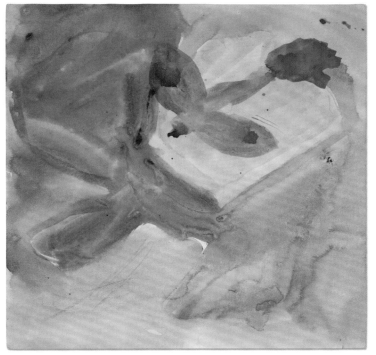

IDA EKBLAD
music: Nils Bech
title: One Year
LP
Norway. 2014

IDA EKBLAD
music: Nils Bech
title: A Sudden Sickness
12"
Norway. 2012

ELMGREEN & DRAGSET
music: Parra for Cuva & Trashlagoon
title: Compiled Works by Parra for Cuva & Trashlagoon
12"
Germany. 2015. Edition of 400

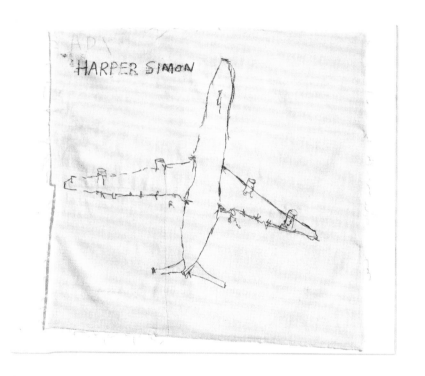

TRACEY EMIN
music: Harper Simon
title: Harper Simon
CD
UK / Europe / US. 2009

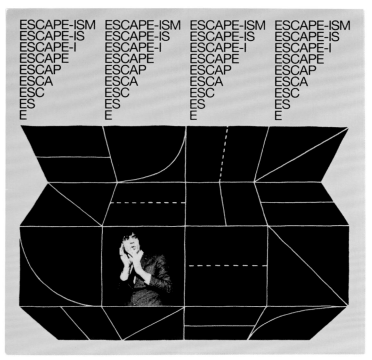

EXPERIMENTAL JETSET
music: Ian Svenonius & Experimental Jetset
title: Alphabet Reform Committee
7"
Netherlands. 2018. Edition of 250

EXPERIMENTAL JETSET
music: Escape-Ism
title: Introduction To Escape-Ism
LP
US. 2017

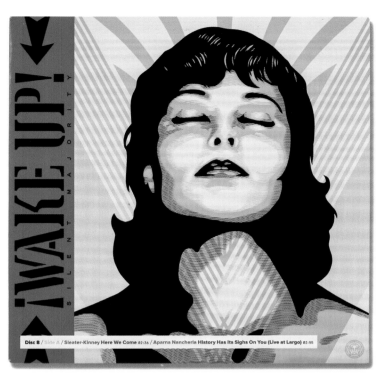

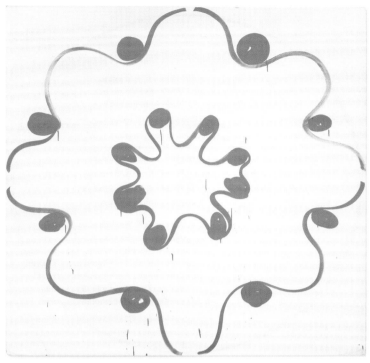

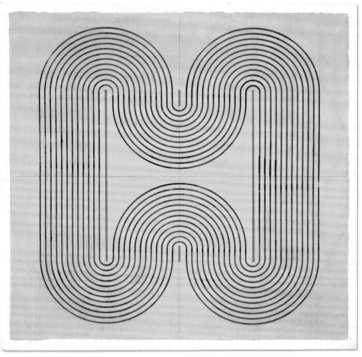

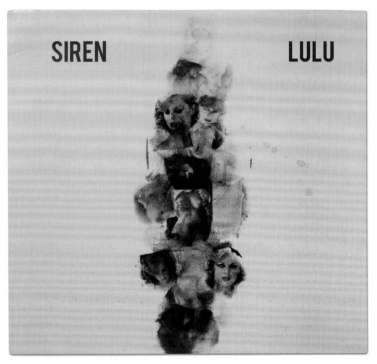

SHEPARD FAIREY
music: Various
title: 7-inches for Planned Parenthood
10 × 7" pink vinyl box set
US. 2017. Edition size unknown

ELISE FERGUSON
music: THE minor ARTS
title: Motion and Time
LP
US. 2018. Edition of 333

AMY FELDMAN
music: Thurston Moore & Frank Rosaly
title: Marshmallow Moon Decorum
CD
US. 2016

ERIK FOSS
music: Siren
title: Lulu
12"
Germany. 2017

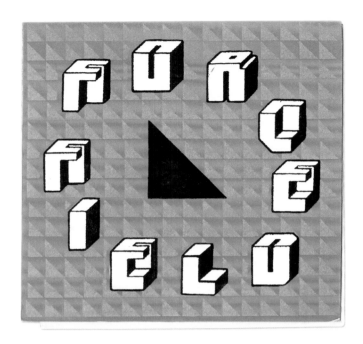

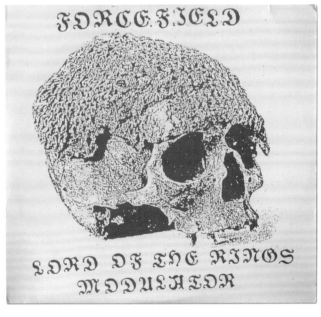

FORCEFIELD
music: Lightning Bolt / Forcefield
title: Lightning Bolt / Forcefield
7", transparent green vinyl
US. 1997. Edition size unknown

FORCEFIELD
music: Forcefield
title: Lord Of The Rings Modulator
2 × LP
US. 2003. Edition of 500

KATHARINA FRITSCH
music: Katharina Fritsch
title: Krankenwagen
7"
Switzerland. 1990. Edition size unknown.

KATHARINA FRITSCH
music: Katharina Fritsch
title: Mühle
7"
Switzerland. 1990. Edition size unknown.

KATHARINA FRITSCH
music: Katharina Fritsch
title: Regen
LP
Germany. 1987. Edition size unknown.

KATHARINA FRITSCH
music: Katharina Fritsch
title: Unken
7"
Switzerland. 1990. Edition size unknown.

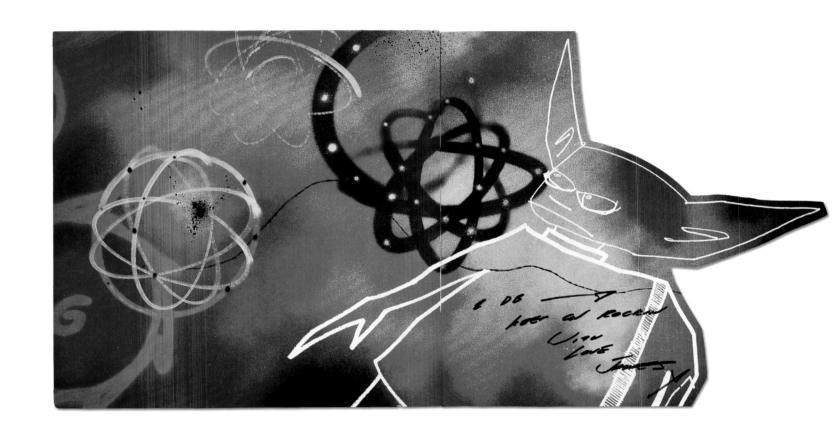

FUTURA
music: UNKLE
title: Rabbit in the Headlights
12" (fold-out. die cut front + back cover)
UK. 1998

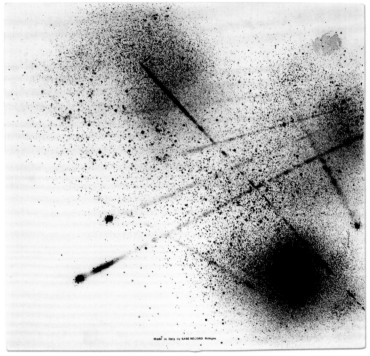

FUTURA
music: Cabaret Voltaire
title: Fools Game / Gut Level
12" (front + back cover)
Belgium. 1983

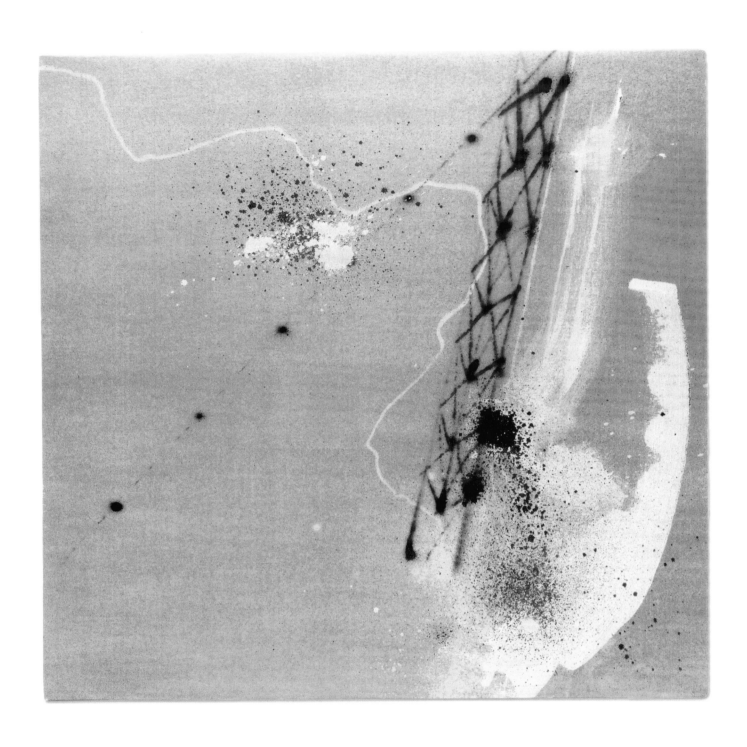

FUTURA
music: DJ Krush
title: Only The Strong Survive
10"
Europe. 1996

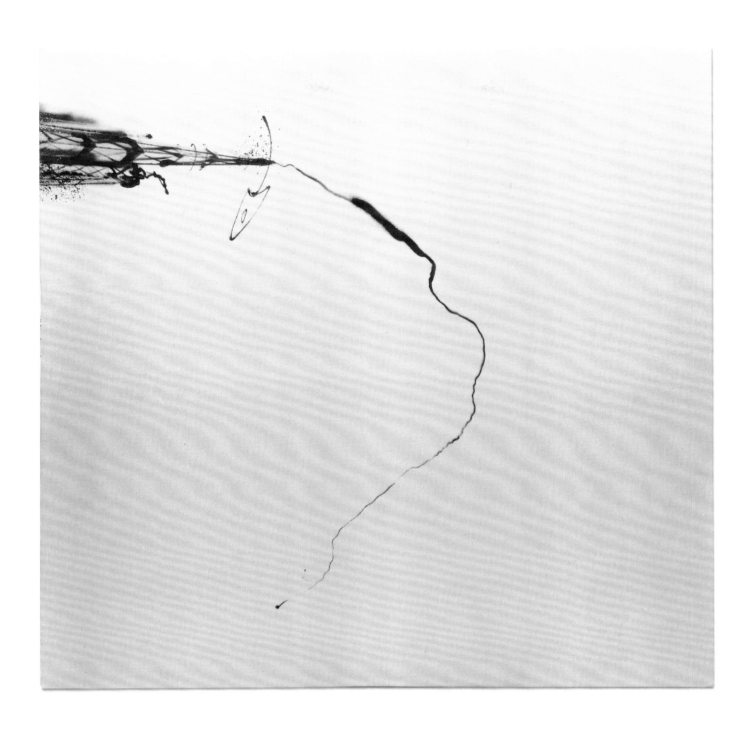

FUTURA
music: DJ Krush
title: Meiso
2 × LP
Europe. 1995

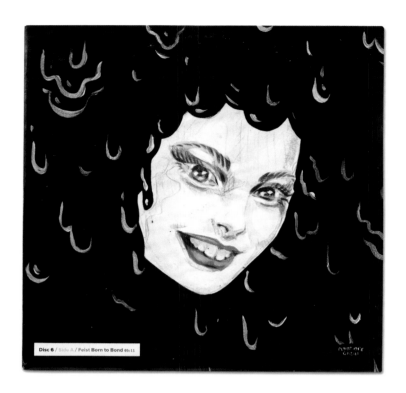

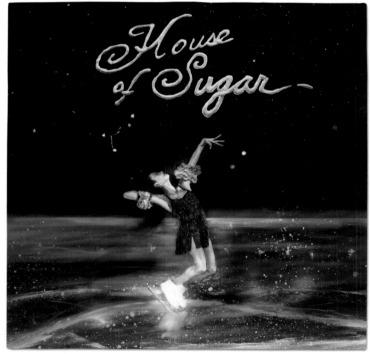

PENELOPE GAZIN
music: Various
title: 7-inches for Planned Parenthood
10 x 7", pink vinyl box set
US. 2017. Edition size unknown

RACHEL GIANNASCOLI
music: Sandy (Alex G)
title: House of Sugar
LP
Europe. 2019

JOHN GIORNO / THE VINYL FACTORY
music: John Giorno
title: I'm Rock Hard (1982–1989)
2 × LP + booklet
US. 2017. Edition of 200 signed

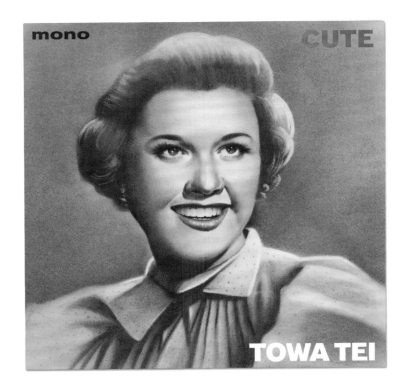

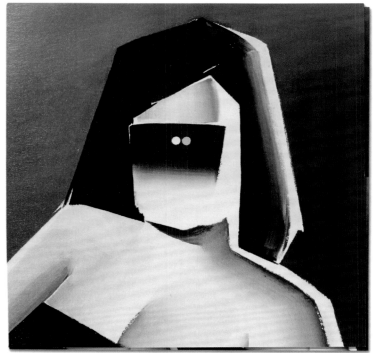

TOMOO GOKITA
music: Towa Tei
title: Cute
LP
Japan. 2015

TOMOO GOKITA
music: Towa Tei
title: 94-14 Covers EP
7"
Japan. 2014

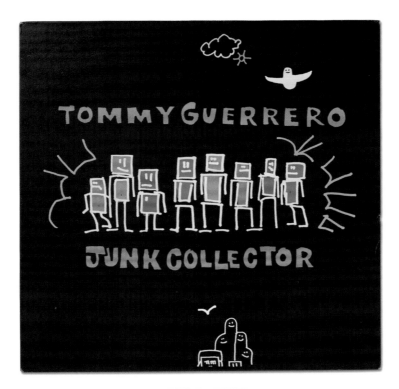

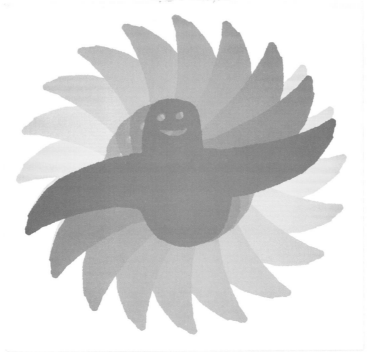

MARK GONZALES
music: Tommy Guerrero
title: Junk Collector
12" maxi-single
France. 2000

MARK GONZALES
music: Tommy Guerrero
title: Rusty Gears Lonely Years
12"
UK. 2001

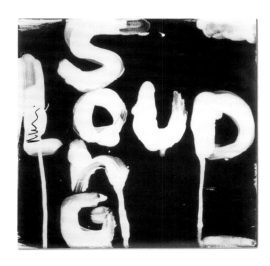

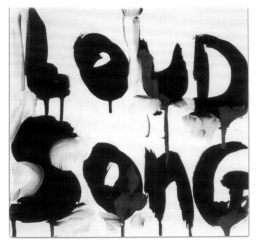

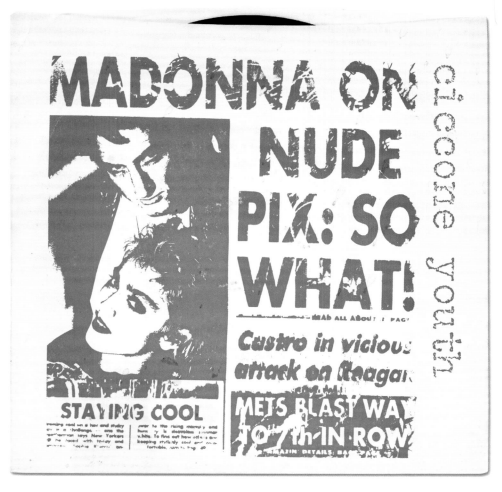

KIM GORDON
music: Richard Prince
title: Loud Song (back + front cover)
12", white vinyl
US. 2016. Edition of 250 signed

KIM GORDON
music: Ciccone Youth
title: Burnin' Up
7"
US. 1986

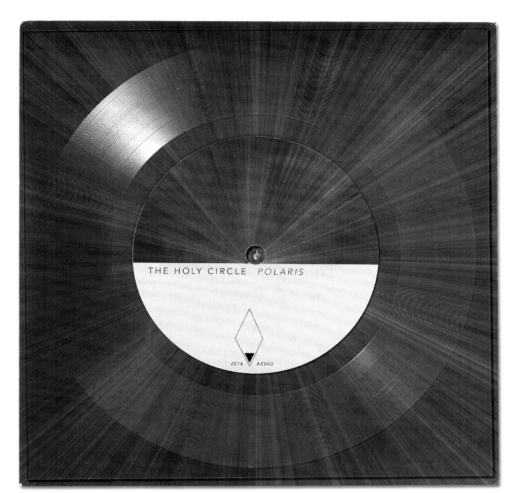

MICHELLE GRABNER
music: Pauline Oliveros / Zeena Parkins
title: Presença Series #01
LP
Portugal. 2015

MICHELLE GRABNER
music: Hubble
title: Hubble Eagle
LP
US. 2013

MICHELLE GRABNER
music: The Holy Circle
title: Polaris
7", single-sided, clear square vinyl
US. 2016. Edition of 30

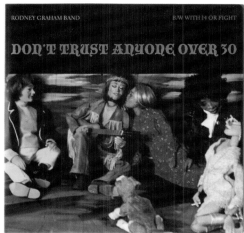

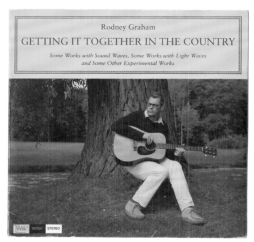

RODNEY GRAHAM
music: Rodney Graham Band
title: Don't Trust Anyone Over 30
7", transparent green vinyl
Canada. 2006. Edition size unknown

RODNEY GRAHAM
music: Rodney Graham
title: Rock Is Hard
2 × LP
Canada. 2003

RODNEY GRAHAM
music: Rodney Graham
title: Getting It Together In The Country
10" + booklet
Germany. 2000. Edition size unknown

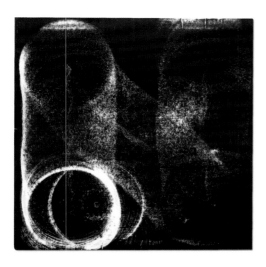

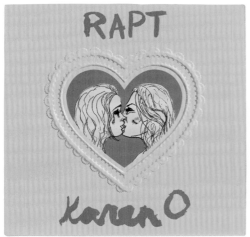

JULIAN GROSS
music: 13 million year old ghost by Nick Zinner
title: 13 million year old ghost
LP
US. 2019. Edition of 250

JULIAN GROSS
music: Karen O
title: Rapt
7", single-sided etched pink vinyl
Europe. 2015

JULIAN GROSS
music: Autolux
title: Soft Scene
7"
US. 2015

JULIAN GROSS
music: Liars
title: Mess On A Mission
12", clear vinyl with embedded string
UK / Europe / US. 2014. Edition of 1,000

JULIAN GROSS
music: Liars
title: Mess (front cover + inner sleeve)
2 × LP + CD, black vinyl
UK / Europe. 2014

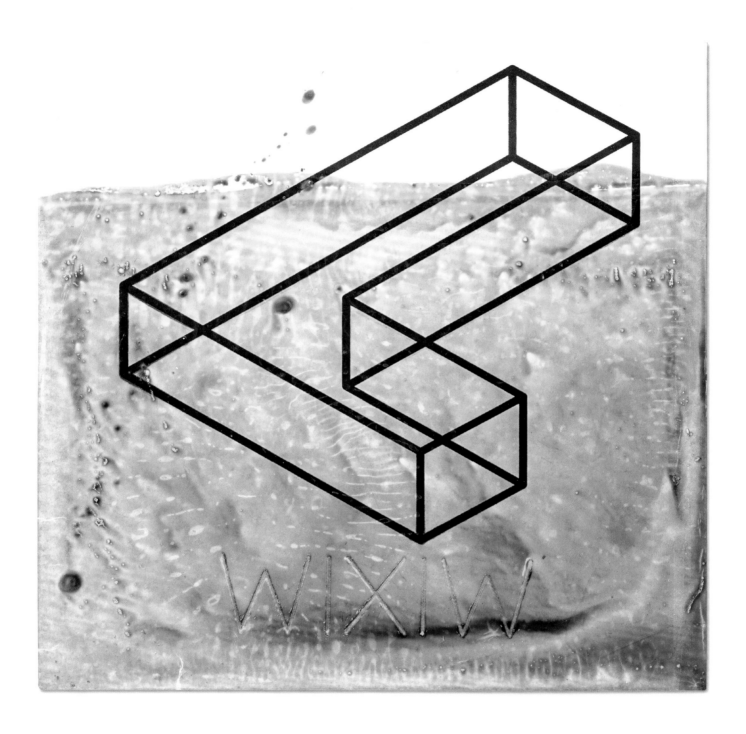

JULIAN GROSS
music: Liars
title: WIXIW
LP + CD, silk screened and embossed, hand dipped in wax
UK. 2012. Edition of 355 numbered

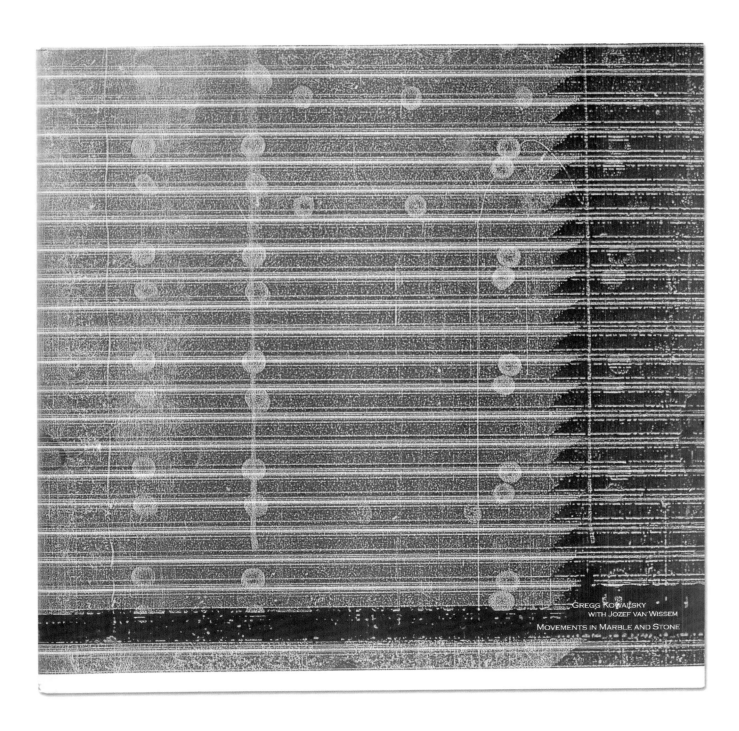

GREGG KOWALSKY
WITH JOZEF VAN WISSEM
MOVEMENTS IN MARBLE AND STONE

WADE GUYTON
music: Gregg Kowalsky With Jozef Van Wissem
title: Movements In Marble And Stone
LP
US. 2012

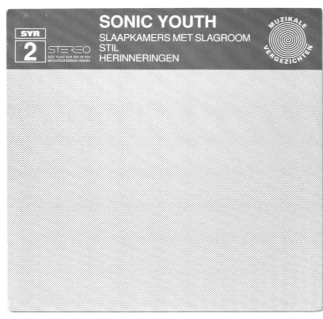

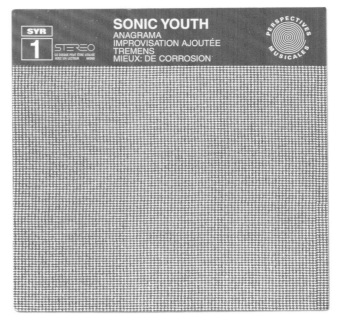

CHRIS HABIB
music: Sonic Youth
title: Goodbye 20th Century
2 × LP
US. 1999

CHRIS HABIB
music: Sonic Youth
title: Slaapkamers Met Slagroom
12" EP, clear blue vinyl
US. 1997

CHRIS HABIB
music: Sonic Youth / Jim O'Rourke
title: Invito Al Ĉielo
12" EP, clear vinyl
US. 1998

CHRIS HABIB
music: Sonic Youth
title: Anagrama
12" EP, red vinyl
US. 1997

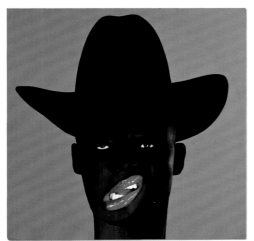

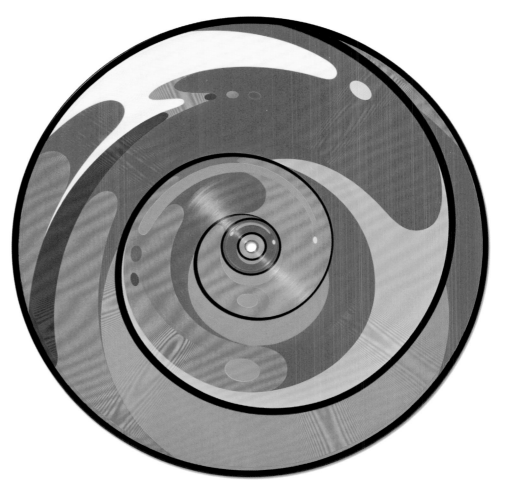

MAYA HAYUK
music: Savath & Savalas
title: Mañana
12" EP
UK. 2004

TOM HINGSTON
music: Young Fathers
title: Cocoa Sugar
LP, blue vinyl
Europe. 2018. Edition size unknown

OLIVER HIBERT
music: King Gizzard
title: Head On / Pill
12" picture disc
UK / Europe / US. 2014. Edition of 300

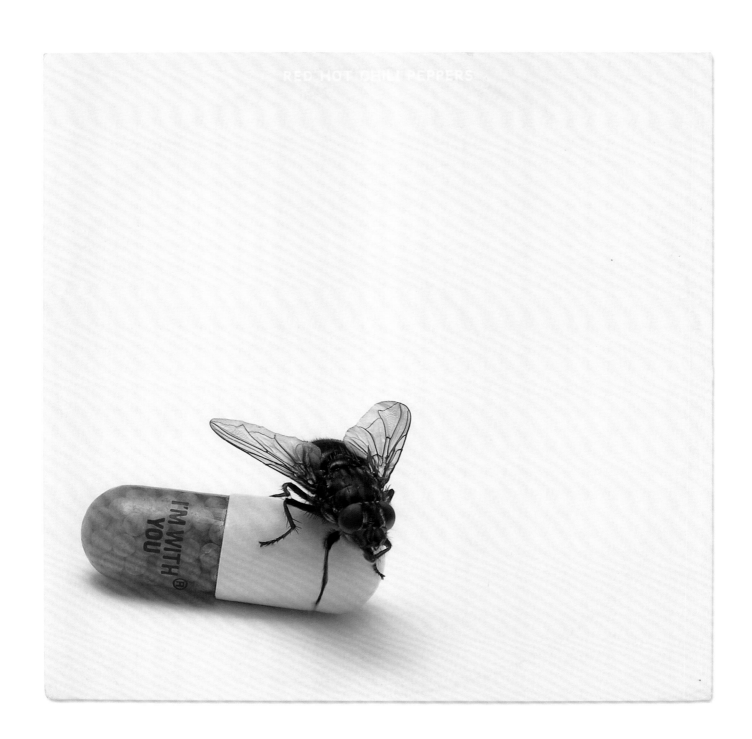

DAMIEN HIRST
music: Red Hot Chili Peppers
title: I'm With You
2 × LP
US. 2011

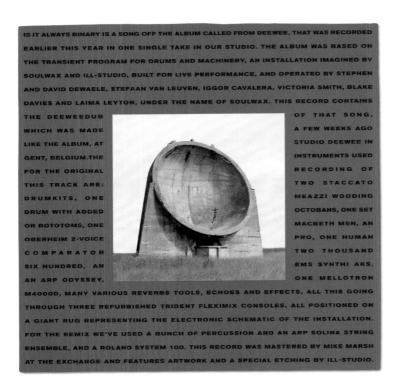

IS IT ALWAYS BINARY IS A SONG OFF THE ALBUM CALLED FROM DEEWEE, THAT WAS RECORDED EARLIER THIS YEAR IN ONE SINGLE TAKE IN OUR STUDIO. THE ALBUM WAS BASED ON THE TRANSIENT PROGRAM FOR DRUMS AND MACHINERY, AN INSTALLATION IMAGINED BY SOULWAX AND ILL-STUDIO, BUILT FOR LIVE PERFORMANCE, AND OPERATED BY STEPHEN AND DAVID DEWAELE, STEFAAN VAN LEUVEN, IGGOR CAVALERA, VICTORIA SMITH, BLAKE DAVIES AND LAIMA LEYTON, UNDER THE NAME OF SOULWAX. THIS RECORD CONTAINS THE DEEWEEDUB OF THAT SONG, WHICH WAS MADE A FEW WEEKS AGO LIKE THE ALBUM, AT STUDIO DEEWEE IN GENT, BELGIUM.THE INSTRUMENTS USED FOR THE ORIGINAL RECORDING OF THIS TRACK ARE: TWO STACCATO DRUMKITS, ONE MEAZZI WOODING DRUM WITH ADDED OCTOBANS, ONE SET OR ROTOTOMS, ONE MACBETH M5N, AN OBERHEIM 2-VOICE PRO, ONE HUMAN COMPARATOR TWO THOUSAND SIX HUNDRED, AN EMS SYNTHI AKS, AN ARP ODYSSEY, ONE MELLOTRON M4000D, MANY VARIOUS REVERBS TOOLS, ECHOES AND EFFECTS, ALL THIS GOING THROUGH THREE REFURBISHED TRIDENT FLEXIMIX CONSOLES, ALL POSITIONED ON A GIANT RUG REPRESENTING THE ELECTRONIC SCHEMATIC OF THE INSTALLATION. FOR THE REMIX WE'VE USED A BUNCH OF PERCUSSION AND AN ARP SOLINA STRING ENSEMBLE, AND A ROLAND SYSTEM 100. THIS RECORD WAS MASTERED BY MIKE MARSH AT THE EXCHANGE AND FEATURES ARTWORK AND A SPECIAL ETCHING BY ILL-STUDIO.

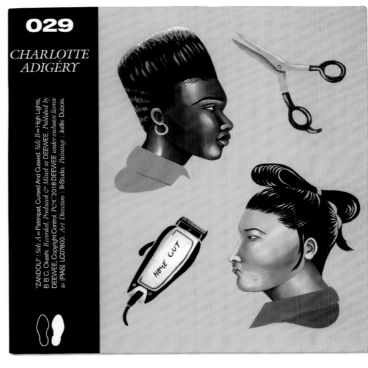

029

CHARLOTTE ADIGÉRY

"ZANDOLI" : Side A = Patérpat, Cursed And Cussed Side B= High Lights. B B C. Osashi. Recorded, Produced & Mixed at DEEWEE. Published by DEEWEE. Copyright Control. ℗ © 2018 DEEWEE under exclusive license to [PIAS] LC07800. Art Direction : Ill-Studio. Painting : Joëlle Dubois.

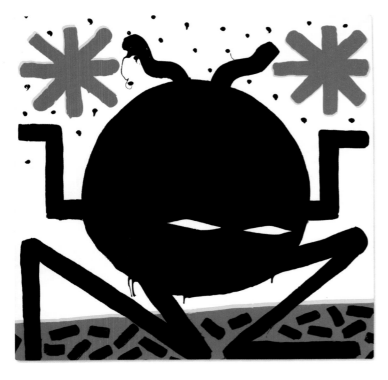

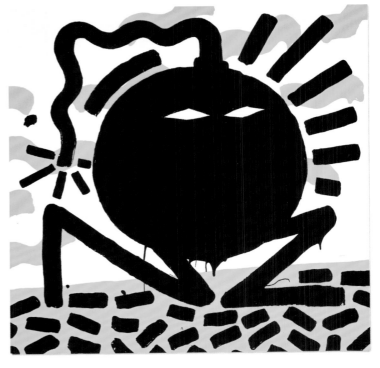

ILL-STUDIO
music: Soulwax
title: Is It Always Binary (DEEWEEDUB)
12" single-sided etched
UK. 2017. Edition of 500

PAUL INSECT / THE VINYL FACTORY
music: 3D On Jupiter
title: 3D On Jupiter
12", black vinyl
UK. 2013. Edition of 300 numbered

ILL-STUDIO / JOËLLE DUBOIS
music: Charlotte Adigéry
title: Zandoli
12" EP
Belgium. 2019

PAUL INSECT / THE VINYL FACTORY
music: 3D, Guy Garvey
title: Battle Box
12", black vinyl
UK. 2013. Edition of 300 numbered

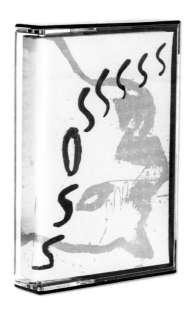

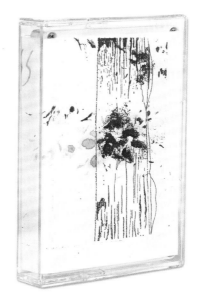

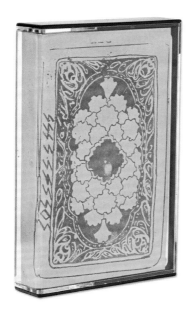

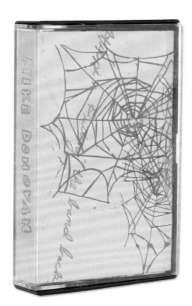

JOHANNA JACKSON
music: Various
title: SSSSSOSS
Cassette compilation
US. 2004. Edition of 100

JOHANNA JACKSON
music: Various
title: SSSSSOSS3
Cassette compilation
US. 2005. Edition of 100

JOHANNA JACKSON
music: Various
title: SSSSSOSS2
Cassette compilation
US. 2005. Edition of 100, watercolor + dog paw print

JOHANNA JACKSON
music: Mike Donovan
title: Hippy's Putting the Band Back Together
Cassette
US. 2004. Edition of 100

TODD JAMES
music: Fudge
title: Lady Parts
LP, marigold vinyl (back cover detail + inner sleeve detail)
US / Europe. 2016. Edition of 200

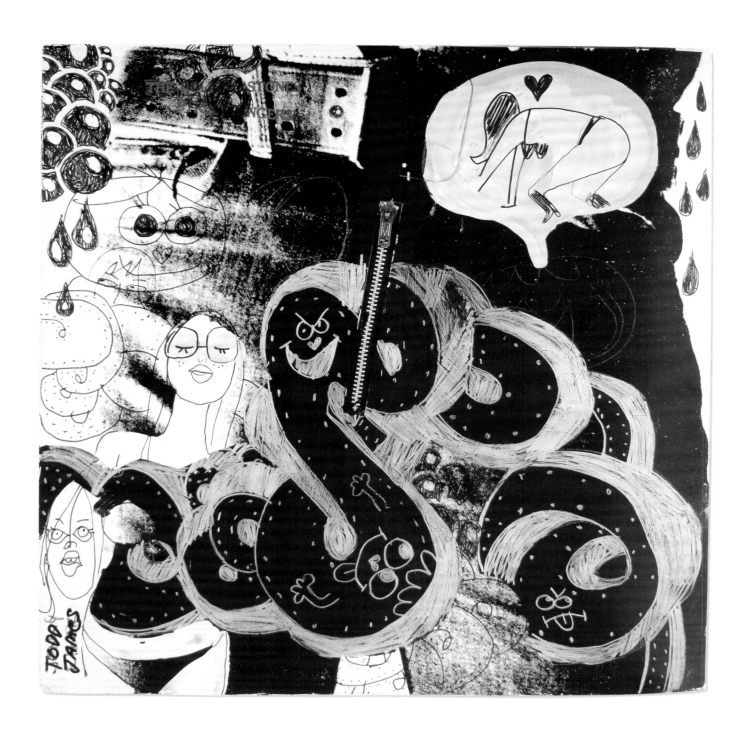

TODD JAMES
music: The Rolling Stones
title: Sticky Fingers
LP
UK. 2003. Original artwork, 1 of 1

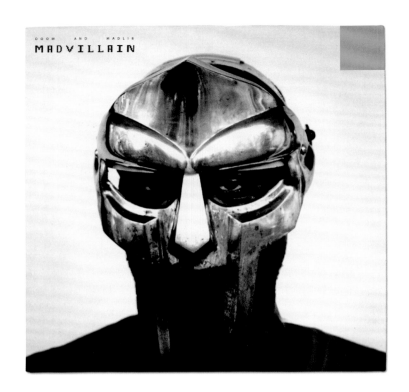

JEFF JANK / ERIC COLEMAN
music: Madvillain
title: Madvillainy
2 × LP
US. 2006

JEFF JANK
music: Madlib
title: Medicine Show #12 & #13: Filthy Ass Remixes
LP
US. 2011. Edition of 1,000

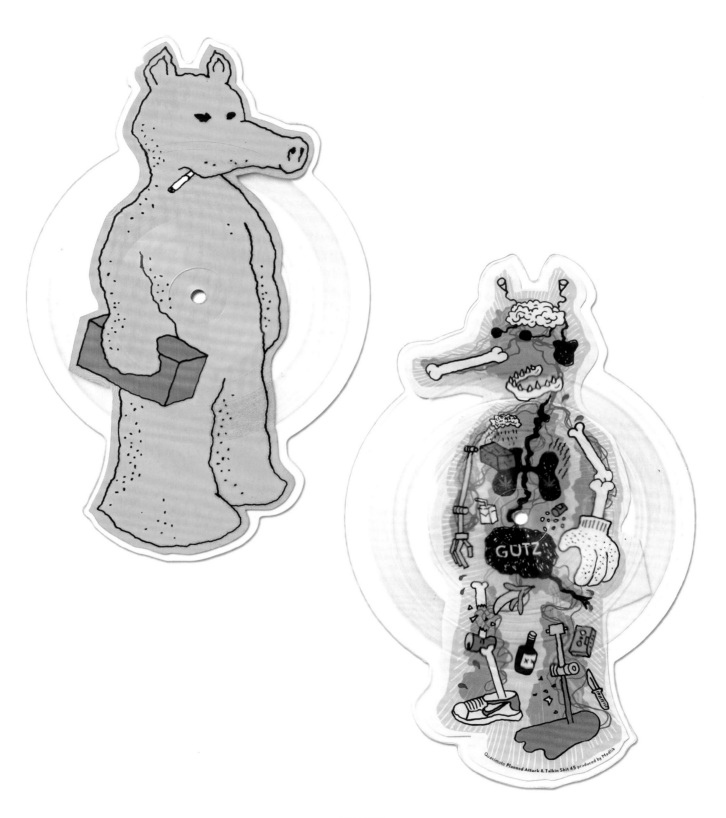

JEFF JANK
music: Quasimoto
title: Talkin' Shit
7", die-cut picture disc (front + back)
US. 2014

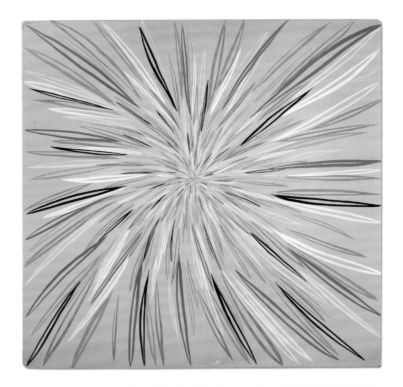

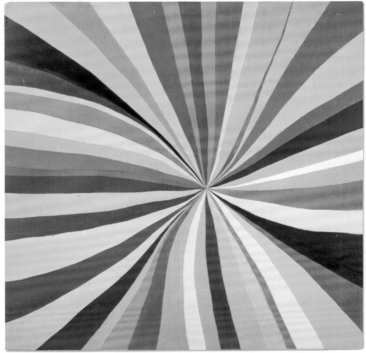

CHRIS JOHANSON
music: Tussle
title: Eye Contact
12"
US. 2003

CHRIS JOHANSON
music: Tussle
title: Don't Stop
12"
US. 2004

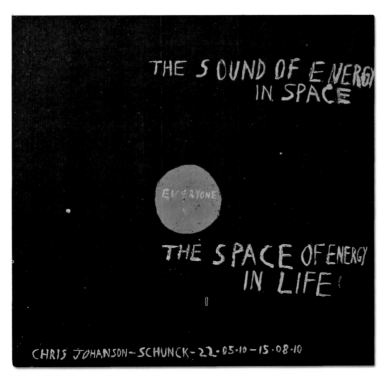

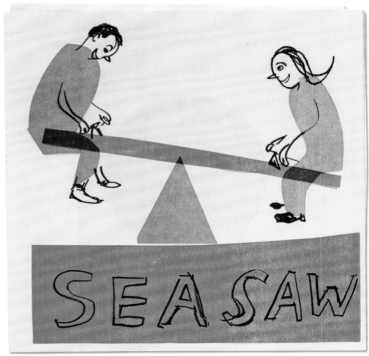

CHRIS JOHANSON
music: IS
title: The Sound Of Energy In Space, The Space Of Energy In Life
LP
Netherlands. 2010

CHRIS JOHANSON
music: Quasi
title: American Gong
LP
US. 2010

CHRIS JOHANSON
music: Seasaw
title: Love And Disaster
7"
US. 1994. Edition of 50

CHRIS JOHANSON
music: Flower Of Flesh And Blood
title: High Life
LP + CD, silk screened
US. 2009

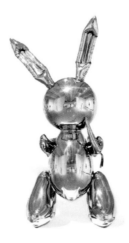

John Cage to David Byrne: Four Decades of Contemporary Music

JEFF KOONS / JASPER JOHNS
music: Various
title: John Cage To David Byrne: Four Decades Of Contemporary Music
CD
US. 2001

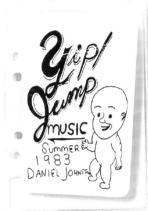

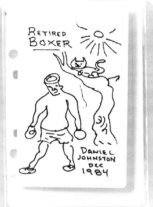

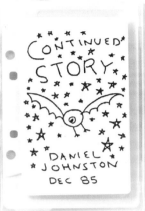

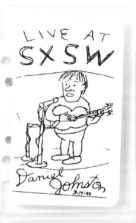

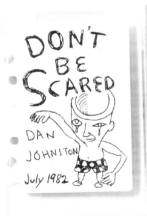

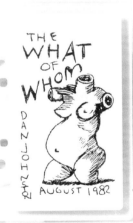

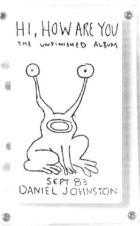

DANIEL JOHNSTON
music: Daniel Johnston
title: see full credits on p. 213
Cassette
US. 1982–1998

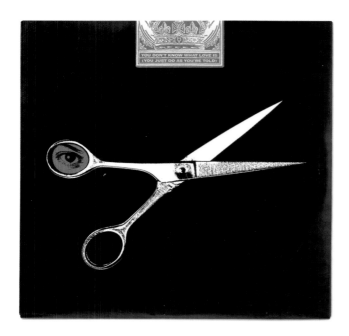

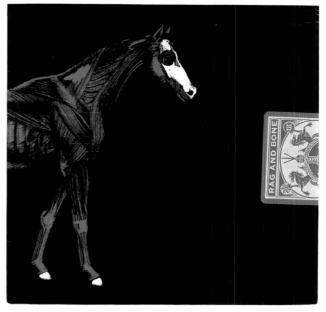

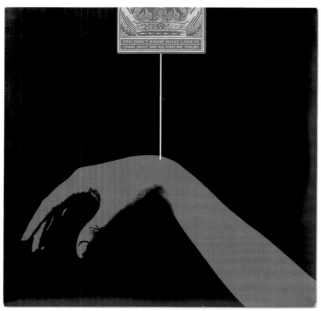

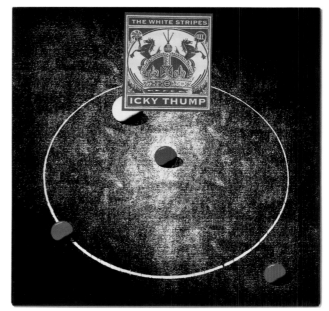

ROB JONES
music: The White Stripes
title: Rag And Bone
7", etched red vinyl
UK. 2007

ROB JONES
music: The White Stripes
title: You Don't Know What Love Is
(You Just Do As You're Told) (version A + B)
7"
UK. 2007

ROB JONES
music: The White Stripes
title: Icky Thump
7"
UK. 2007

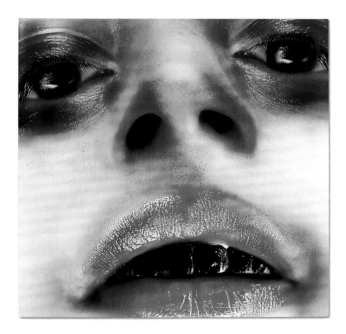

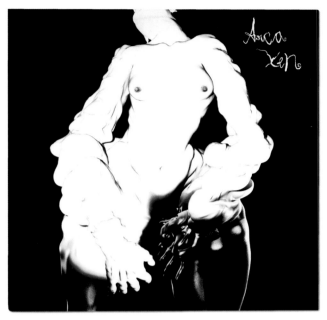

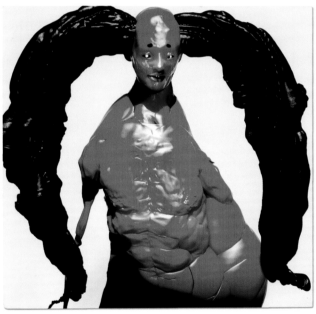

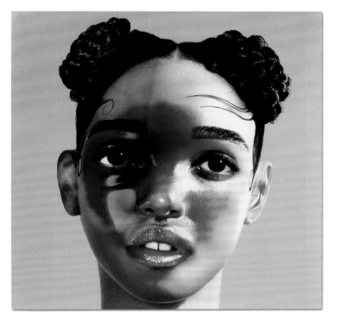

JESSE KANDA
music: Arca
title: Arca
LP + booklet
UK. 2017

JESSE KANDA
music: Arca
title: Xen
LP + booklet
UK. 2014

JESSE KANDA
music: Arca
title: Mutant
2 × LP, red vinyl
UK / Europe. 2016. Edition size unknown

JESSE KANDA
music: FKA Twigs
title: LP1
LP
UK / Europe / US. 2014

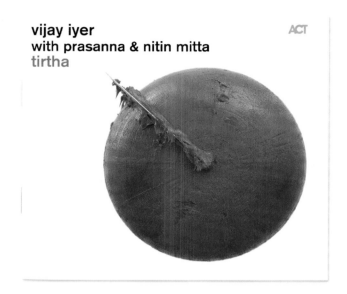

vijay iyer
with prasanna & nitin mitta
tirtha

ACT

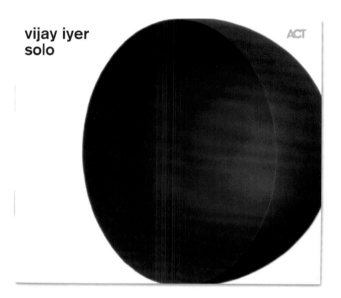

vijay iyer
solo

ACT

ANISH KAPOOR
music: Vijay Iyer With Prasanna & Nitin Mitta
title: Tirtha
CD
Germany. 2011

ANISH KAPOOR
music: Vijay Iyer
title: Solo
CD
Germany. 2010

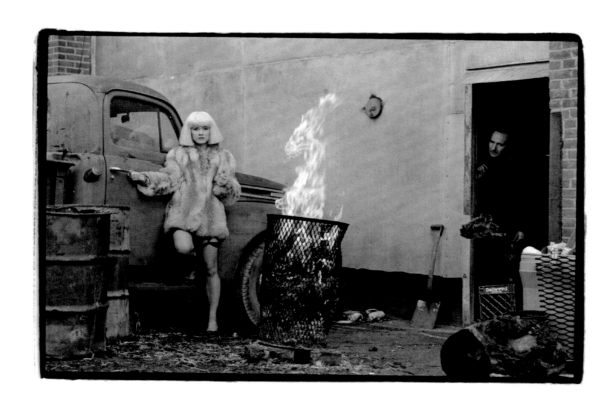

RICHARD KERN
music: Dominatrix
title: The Dominatrix Sleeps Tonight
12", pink vinyl + booklet (detail from interior booklet)
US. 2015 reissue

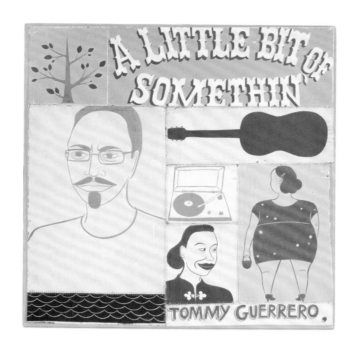

MARGARET KILGALLEN
music: Tommy Guerrero
title: A Little Bit Of Somethin'
LP
UK. 2000

MARGARET KILGALLEN
music: Ovarian Trolley
title: Romeo / Incendiary
7", transparent yellow vinyl
US. 1997

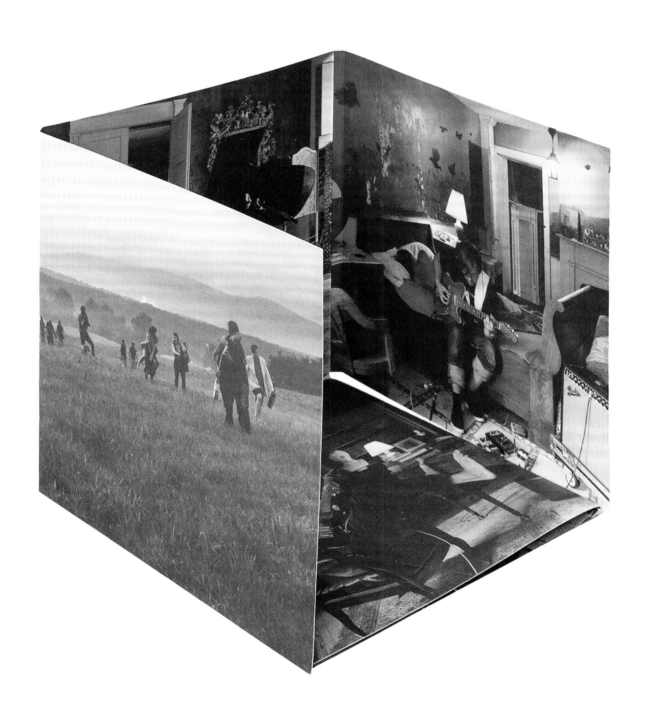

RAGNAR KJARTANSSON / THE VINYL FACTORY
music: Ragnar Kjartansson & The All Star Band
title: The Visitors
LP (multi-panel foldout sleeve)
UK. 2015. Edition of 500

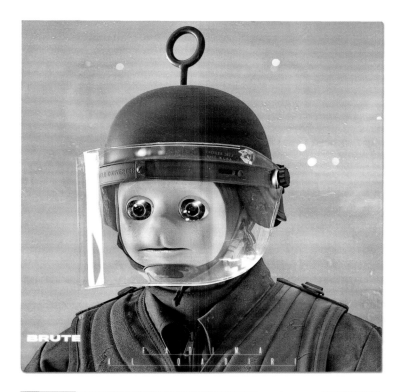

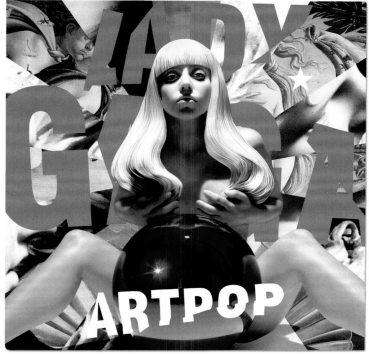

JOSH KLINE
music: Fatima Al Qadiri
title: Brute
LP
UK. 2016

JEFF KOONS
music: Lady Gaga
title: Artpop
2 × LP
US / Canada. 2014

BILL KOULIGAS
music: R/S
title: USA
LP, silk-screened pvc sleeve
Germany. 2011. Edition of 500

BILL KOULIGAS
music: John Wiese / Evan Parker
title: C-Section
LP, silk-screened pvc sleeve
Germany. 2010. Edition of 330 hand numbered

BILL KOULIGAS
music: James Hoff
title: How Wheeling Feels When the Ground Walks Away
LP, single-sided picture disc
Germany. 2011. Edition of 200

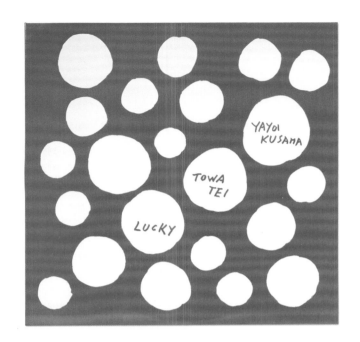

YAYOI KUSAMA
music: Towa Tei
title: Lucky
LP
Japan. 2013

BARBARA KRUGER
music: Growing Up Skipper
title: Use Only As Directed
7"
US. 1992. Edition of 500, all copies numbered as #1

LACRA
music: Klein
title: Lifetime
LP
UK. 2019

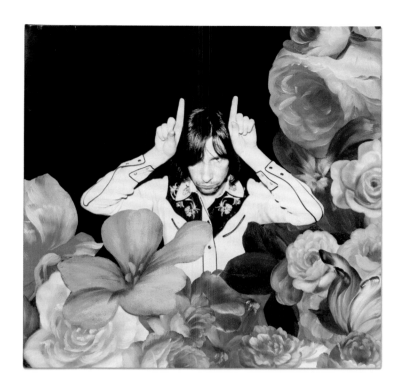

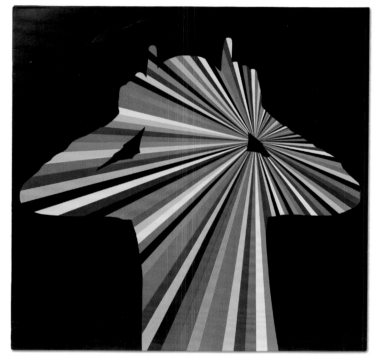

JIM LAMBIE
music: Primal Scream
title: More Light
2 × LP + CD
UK. 2013

JIM LAMBIE
music: Primal Scream
title: It's Alright, It's OK
12"
UK / Europe. 2013

WES LANG
music: Grateful Dead
title: Spring 1990: So Glad You Made It
4 × LP
US. 2012. Edition of 9,000 numbered

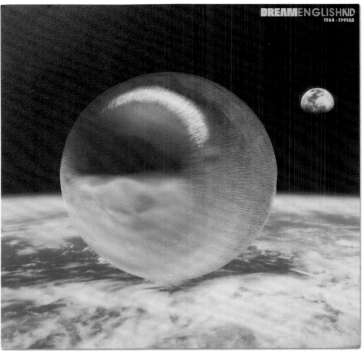

MARK LECKEY
music: Hecker / Leckey
title: Hecker Leckey Sound Voice Chimera
LP (front cover + inner sleeve)
Germany. 2015

MARK LECKEY
music: Mark Leckey
title: Dream English Kid 1964–1999 AD
LP
UK. 2016. Edition of 500

MARK LECKEY
music: Mark Leckey
title: Exorcism of the Bridge @ Eastham Rake
10"
Europe. 2018. Edition of 500

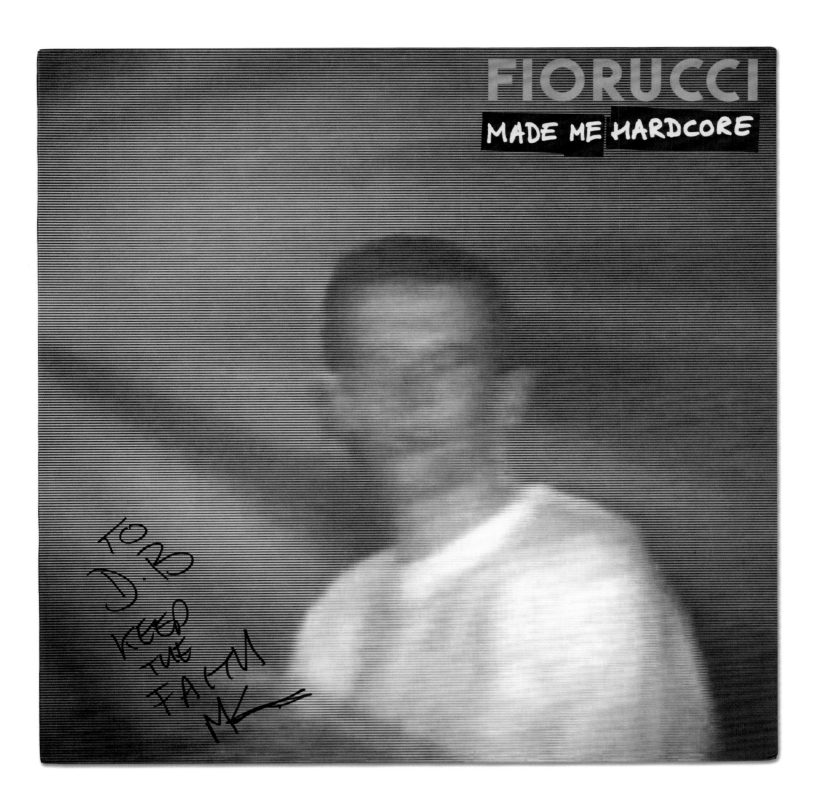

MARK LECKEY
music: Mark Leckey
title: Fiorruci Made Me Hardcore
LP
UK. 2012. Edition of 500

PHIL LEE
music: The xx, Jamie xx, Gil Scott-Heron, Four Tet
title: full credits on p. 213
UK. 2009–2016

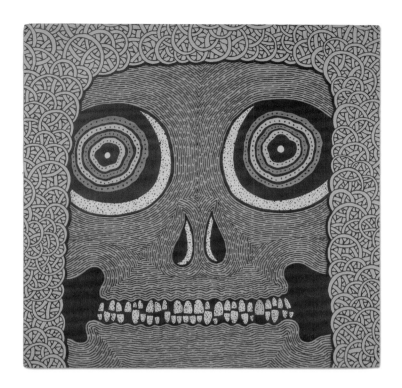

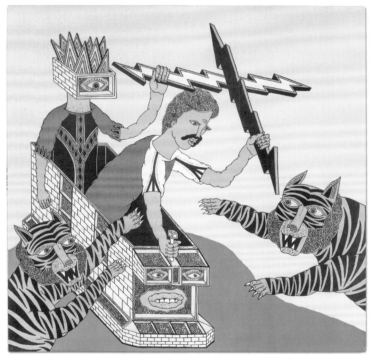

MATT LEINES
music: Pink Skull
title: Gonzo's Cointreau
12"
US. 2007

MATT LEINES
music: The Sads
title: Rough Stabs
12", white vinyl
US. 2006. Edition of 100

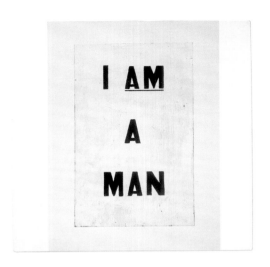

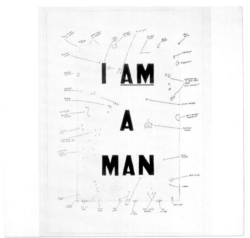

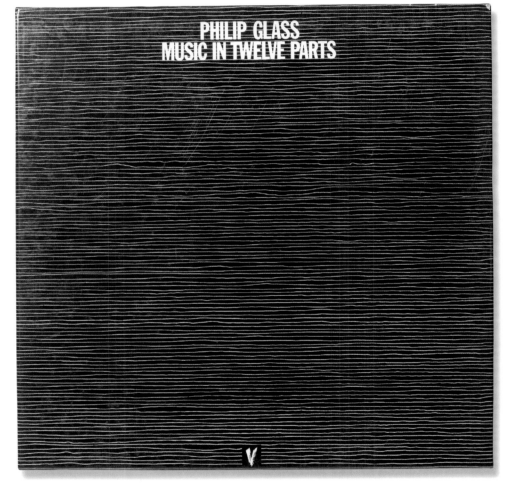

GLENN LIGON
music: Ron Miles
title: I Am A Man
LP (front + back cover)
Germany. 2017

SOL LEWITT
music: Philip Glass
title: Music In Twelve Parts
6 × LP box set
Germany. 1988

ANTHONY LISTER
music: Autolux
title: Pussy's Dead (interior insert)
LP
US. 2016

PETER LIVERSIDGE
music: Low
title: Double Negative
LP, clear vinyl
US / Europe. 2018. Edition size unknown

ROBERT LONGO
music: Glenn Branca
title: The Ascension
LP
US. 1981

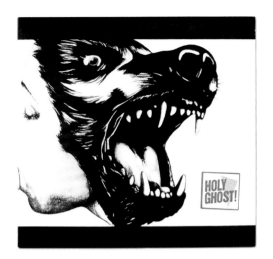

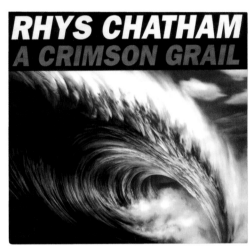

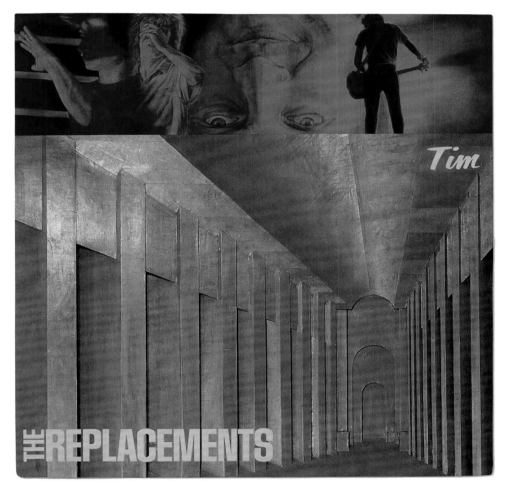

ROBERT LONGO
music: Holy Ghost!
title: Dynamics
2 × LP, pink marbled vinyl
US. 2013

ROBERT LONGO
music: Rhys Chatham
title: A Crimson Grail
CD
US. 2010

ROBERT LONGO
music: The Replacements
title: Tim
LP
US. 1985

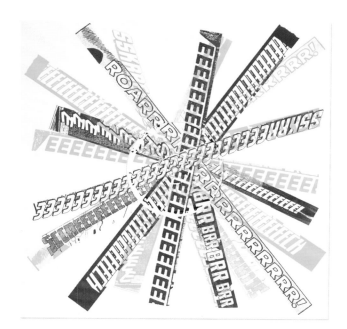

CHRISTIAN MARCLAY / THE VINYL FACTORY
music: Thurston Moore
title: Live at White Cube
LP
UK. 2015. Edition of 500

CHRISTIAN MARCLAY / THE VINYL FACTORY
music: David Toop
title: Live at White Cube
LP
UK. 2015. Edition of 500

CHRISTIAN MARCLAY / THE VINYL FACTORY
music: Laurent Estoppey
title: Live at White Cube
LP
UK. 2015. Edition of 500

CHRISTIAN MARCLAY / THE VINYL FACTORY
music: Elliott Sharp
title: Live at White Cube
LP
UK. 2015. Edition of 500

CHRISTIAN MARCLAY / THE VINYL FACTORY
music: John Butcher
title: Live at White Cube
LP
UK. 2015. Edition of 500

HEIKKI LOTVONEN
music: Overmono
title: Le Tigre / Salt Mix
12"
UK. 2019

STEFAN MARX
music: Christopher Rau
title: Yamato
12"
Germany. 2016

STEFAN MARX
music: Rhythm Of Paradise
title: Dreams
12"
Germany. 2015

STEFAN MARX
music: Lawrence
title: Manhattan
12" EP
Germany. 2017

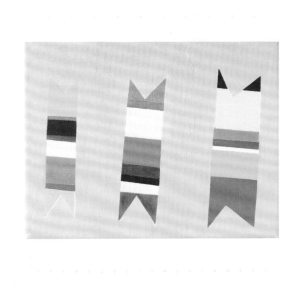

ANDREW MASULLO
music: The Nels Cline Singers
title: Macroscope
LP
US. 2014

ALICIA MCCARTHY
music: Crickets
title: Drilled Two Holes
12"
US. 2020

Richard Prince

Artist whose plundered mythology turned the tragi-comic landscape of America into high art

RICHARD PRINCE, who has died aged 57, was the most influential artist of his generation and a restless connoisseur of the underbelly of the American Dream.

He was best known for his grainy photographs of Stetsoned cowboys lifted directly from the famous Marlboro advertising campaign – tragic figures in the mold of John Wayne who ride resolutely into their own sunsets – and for paintings consisting of broad fields of flat color stenciled with paper-thin jokes taken from the pages of outdated humor compendiums.

His practice of re-photographing the pages of magazines introduced the term 'appropriation' into the art lexicon. The artist himself gave a more frank account of his technique, preferring to call it theft or, sometimes, 'sharing.'

Prince possessed an unerring eye for the iconic and yet terminal image. He strip-mined popular culture, from its glossy, sheened core, dreamed up in the heads of generations of advertising executives, to its abandoned and dilapidated hinterlands. His deadpan offerings came without commentary. Instead, populated by stern-faced, inscrutable fashion models, topless biker chicks, metal heads, surfers and a parade of alcoholics, adulterers and traveling salesmen trailing bad punch lines, they insisted only on their right to join the canon of high-art.

Notoriously, in 1983 he opened his own "gallery" in a small rented storefront on Manhattan's Lower East Side. The only artwork displayed was a single photograph in an ornate gilt frame, its title, 'Spiritual America', borrowed from a 1923 photograph by Alfred Stieglitz showing a gelded stallion's crotch. The picture was of a naked, prepubescent Brooke Shields, her body oiled and dripping with sleaze and pedophile association.

The original, taken by a commercial photographer, Gary Gross, with the permission of Shields's mother, was, as Prince recalled, "a very Dantesque, very spooky image. For me it became an image of what photography can do and how it can get out of hand, how it can develop a life of its own, a kind of photographic ego."

For the duration of the exhibition, Prince went underground, fueling rumors that he had fled to the West Coast, been subpoenaed, or held accountable for his appropriation in less legal, more sinister ways. By pimping the image of the child star, he put those who sought it out in the embarrassing position of having to admit their own complicity in its illicit eroticism.

Prince's aim in re-photographing previously published images was, he said, to "get as close as possible to the real thing." The unsettling implication of his work was that the experience of living in 20th century America was not merely dominated by the invented aspirations of advertising, but was fundamentally defined by them.

Later, having removed himself to the Catskills area of upstate New York, he made a large body of 'landscape' photographs. Shot outdoors with indoor film, these images of impoverished yards, tire planters and abandoned basketball hoops have the sun-ruined, bluish cast of a cheap mail-order catalogue.

Prince was a consummate fan, and his stolen images of 'mainstream cults' were all the more powerful for being devoid of any vampiric quality. Accused of sexism for the depictions of women which he chose to reproduce, he replied, "Well, as far as the biker chicks are concerned, I just wouldn't mind being one... I like what I think they look like, or perhaps what they are."

His main concern was with the slippery nature of myths in popular culture, and with their tenuous but deeply embedded partnership with reality. 'I never had a penny to my name, so I changed my name,' ran one of his laconic texts, indicating the easy interchangeability of truth and identity.

His own artistic persona was accordingly elusive. For many years he encouraged his reputation as a loner, and the interviews he gave tended to be conducted with himself (on one occasion, in the fictitious guise of the writer J.G. Ballard). His self-styled portraits included that of the paint-spattered artist, with more than a nod to Hans Namuth's famous image of Jackson Pollock as "Jack the dripper." His collaborations with the gallerist Colin de Land were made under the pseudonym 'John Dogg'.

Prince's work was suffused with pathos and loss. A tragedian, he understood the point where the tragic and the comic meld. As he observed of a group of his canvases, "The jokes are funny, but the paintings are not."

Richard Prince was born on August 6 1949 in the Panama Canal Zone. By his own account, his parents were spies who worked for an organization called the Office of Strategic Services. His father "did something in defoliants in Vietnam".

In 1954 the family moved to Braintree, Massachusetts, a suburb of Boston. After graduating high school in 1967 he spent several months in Spain and Italy touring art museums. On his return to America he attended an alternative college in Maine, managing to avoid being drafted when he was called up in 1971.

In 1973, after applying to the San Francisco Art Institute without success, he moved to New York and took a job in the tearsheets department at the Time-Life building, where he built a makeshift photographic studio in the basement. Ripping up such magazines as People, Fortune, Sports Illustrated and Time and delivering the editorial pages to the appropriate departments, he was left with the advertising pages. "These images of happy couples were supposed to represent something," he said later, "but they didn't really mean anything to me. So I began to use a camera to make fake photographs of the ads."

A typical example of his early work was titled 'Three Women Looking in the Same Direction', a self-descriptive work in which he photographed three original color advertisements and reprinted them as black-and-white images.

His first solo exhibition was at Metro Pictures gallery in 1980. Along with such artists as Cindy Sherman and Sherrie Levine, he began to be grouped with what became known as the Pictures Generation, named after the title of a show organized by the writer Douglas Crimp (in which Prince himself had declined to be included). While many of his artist contemporaries began to benefit from the frenzied art boom of the 1980s, Prince and his work remained largely ignored, the special interest of a small, informed group of aficionados.

In the mid-1980s he began producing hand-written jokes on paper, soon transferred to canvas via a silkscreen process. Literally jokes on painting, their lateral bands of text made complex allusions to Barnett Newman's sublime "zips" and to the history of heroic American abstract expressionism, perversely allowing him to make 'real' paintings in the process.

In 1988 he began to send off for muscle-car hoods, which he painted in primer gray and stock-car candy-colors to reveal an enigmatic and threatening intent in their angled lines.

'Celebrities', an ongoing series, consisted of 8x10 inch promotional photographs autographed by their subjects, usually in Prince's own hand. In 2003 he exhibited a series of 'Nurse Paintings', based on the covers of pulp paperback novels. As the value of his work began to skyrocket in the early 2000s, he responded by making paintings plastered with personal checks.

Throughout his career, Prince was a prolific and inspired maker of artist's books. Usually consisting of uninterrupted sequences of photographs, they offered him unlimited freedom to curate his world. Their hybrid combination of the photographic and the literal provide the most accurate chronicle of his shifting thought processes.

In 1993 Prince created 'First House', an ominous installation in a condemned tract house in Venice, Los Angeles, which was littered with particularly dark and mean joke paintings, selections of obscure magazines and sculptures. The project was a kind of idealized museum of the artist's aesthetic in which, in the words of one observer, "the circuitry of human relations was completely shorted out and charred." A decade later he made 'Second House' in upstate New York, which was subsequently purchased in toto by the Guggenheim Museum.

Prince's work was exhibited and collected widely in the United States, Europe and elsewhere. He was given a retrospective at the Whitney Museum of American Art in 1992.

Richard Prince married, first, Lisa Spellman (marriage dissolved). He married secondly, Noel Grunwaldt; they had a daughter.

Prince (1991): unsettling work posed questions of authenticity and possession

Adam McEwen
Obituaries

Side One
Untitled (Richard)
Side Two
Untitled (Melvins)

Recorded by Justin Luke/AVA
Audio Visual Arts, New York

Adam McEwen © 2011

From the Nursery
℗ and © 2011 FTN 005

53/400

ADAM MCEWEN
music: Adam McEwen
title: Obituaries
LP, white vinyl
US. 2011. Edition of 400

BARRY MCGEE
music: Anonstop, 40 Thieves, Bézier, The Beat Broker
title: 415-PR10
12"
US / Canada. 2016

BARRY MCGEE
music: Towa Tei
title: Sunny
CD (front cover + interior image)
Japan. 2011

BARRY MCGEE
sound: Field Recordings
title: Untitled
7", silk-screened on clear, square vinyl
Japan. 2018

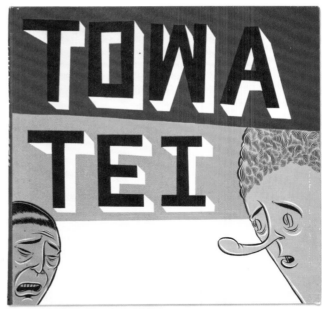

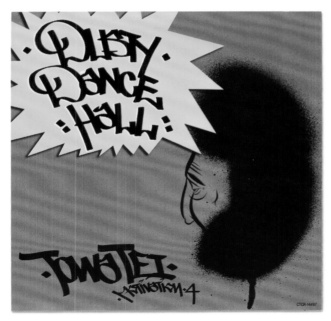

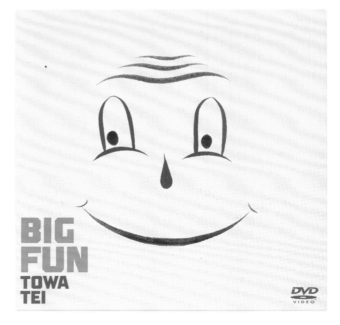

BARRY MCGEE
music: Towa Tei
title: Big Fun
CD
Japan. 2009

BARRY MCGEE
music: Towa Tei
title: Motivation 4 - Dusty Dance Hall
CD
Japan. 2006

BARRY MCGEE
music: Towa Tei
title: Flash
CD
Japan. 2005

BARRY MCGEE
music: Towa Tei
title: Big Fun
CD + DVD (interior image)
Japan. 2009

RYAN MCGINLEY
music: Sigur Rós
title: Með Suð Í Eyrum Við Spilum Endalaust
2 × LP
US. 2008

RYAN MCGINLEY
music: Sigur Rós
title: Inní Mér Syngur Vitleysingur
CD single
UK. 2008

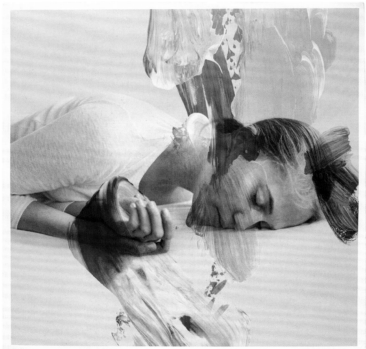

TAYLOR MCKIMENS
music: Matt and Kim
title: Almost Everyday
LP (interior detail)
US. 2018. Edition size unknown

MIKE MILLS
music: The National
title: I Am Easy To Find
2 × LP
US. 2019

128

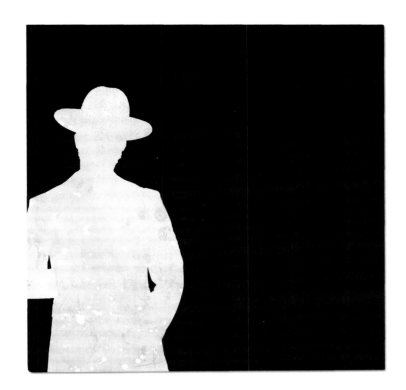

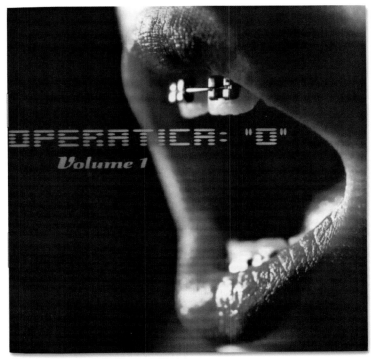

HAYDEN MILLER
music: Ben Williams
title: I Am A Man
LP
US. 2020. Edition of 1,000

MARILYN MINTER
music: Operational
title: "O" - Volume 1
CD
US. 2000

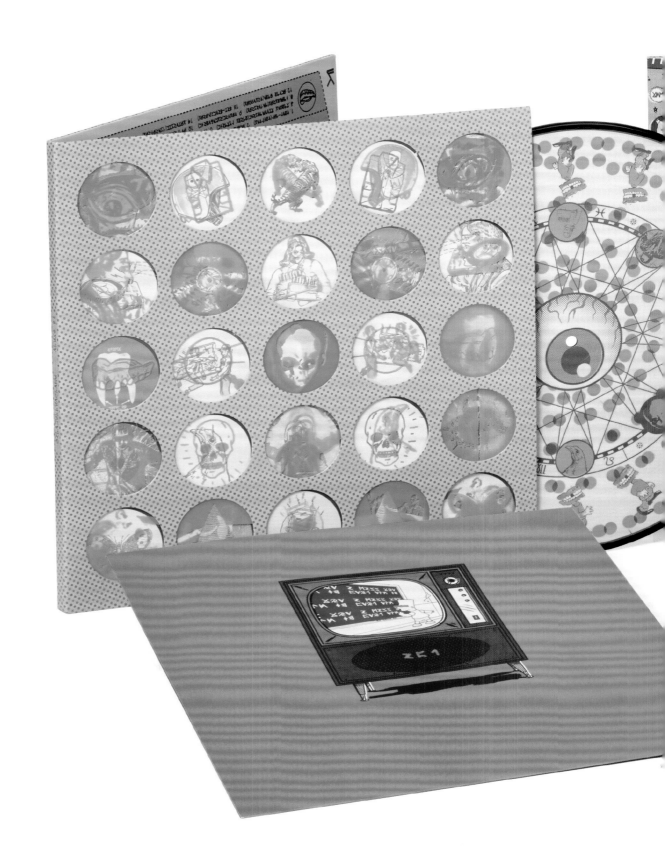

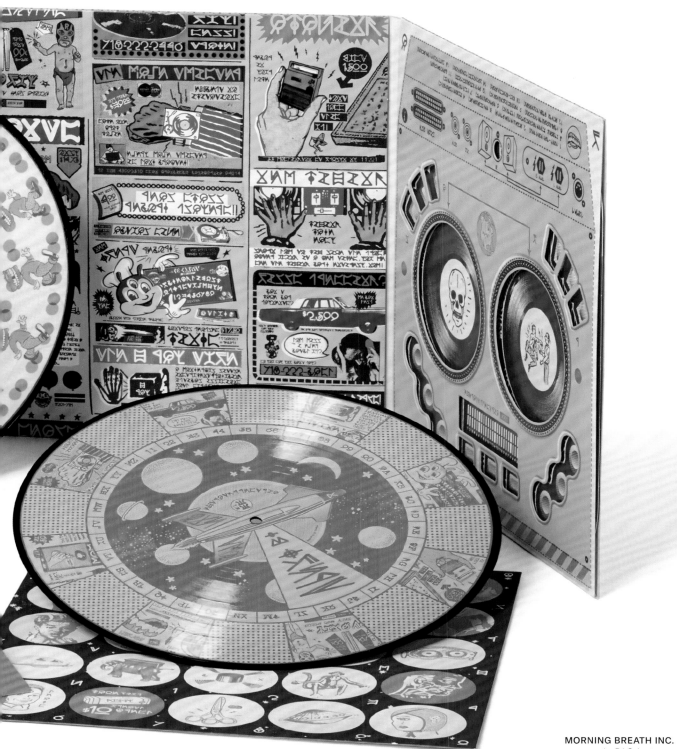

MORNING BREATH INC.
music: DJ Q-bert
title: Extraterrestria
9 × 12" + 2 × LP + 2 × CD
US. 2017. Edition of 50

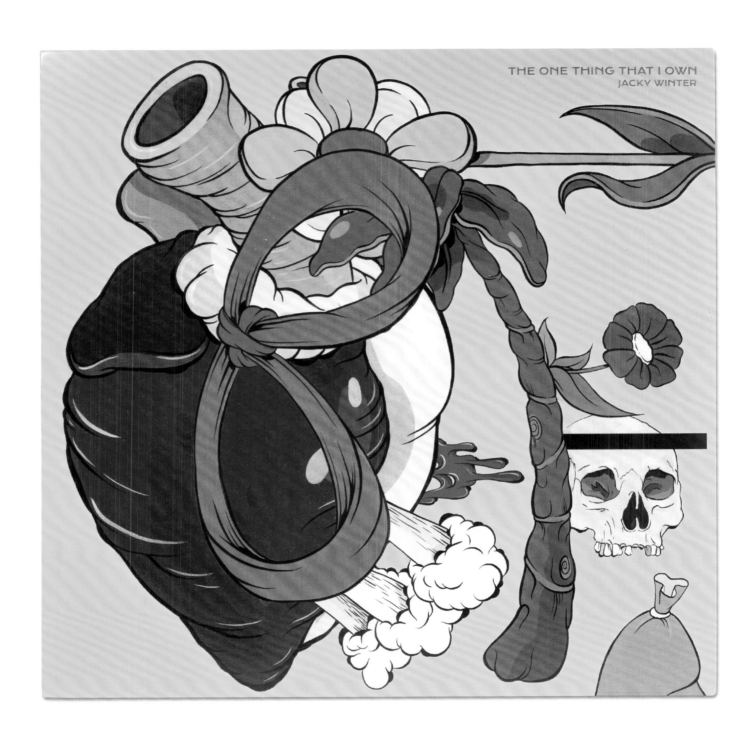

MARK MULRONEY
music: Jacky Winter
title: The One Thing That I Own
12" EP
US. 2019. Edition of 200

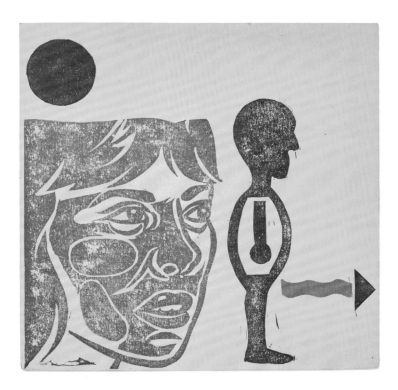

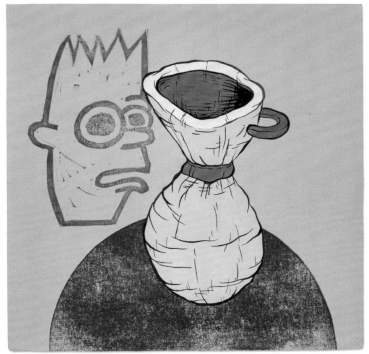

MARK MULRONEY
music: Mark Mulroney + Lisa Mulroney
title: Art Saturday Field Recordings #2 + #3
7", clear vinyl
US. 2019. Edition of 20

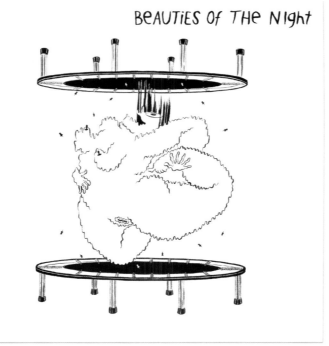

BEAUTIES Of THE NIghT

TAKASHI MURAKAMI
music: Nobukazu Takemura
title: Finale: For Issey Miyake By Naoki Takizawa
CD
Japan. 1999

EBECHO MUSLIMOVA
music: BeaUtiEs of THe NIghT
title: Use Filters
12" mini-album
Austria. 2018. Edition of 400

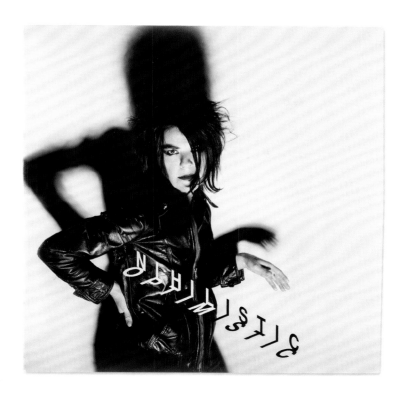

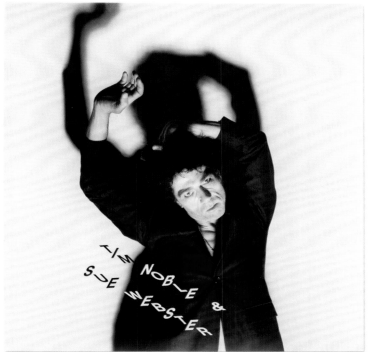

TIM NOBLE / SUE WEBSTER / THE VINYL FACTORY
music: Tim Noble & Sue Webster
title: Nihilistic Optimistic
2 × 12", white vinyl + black vinyl (front + back cover)
UK. 2012. Edition of 150

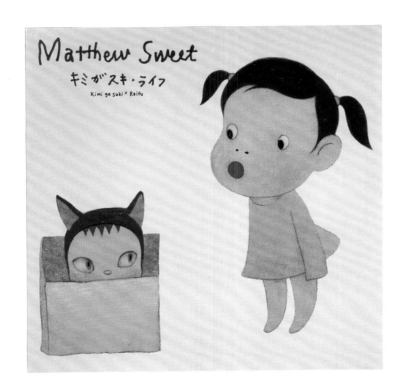

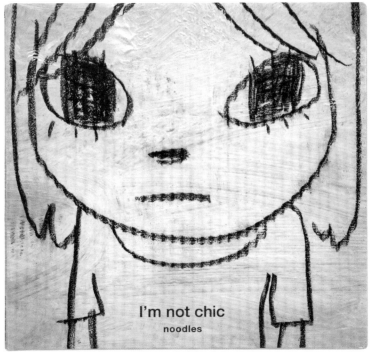

YOSHITOMO NARA
music: Matthew Sweet
title: キミがスキ・ライフ
CD
Japan. 2003

YOSHITOMO NARA
music: Noodles
title: I'm Not Chic
CD
Japan. 2019

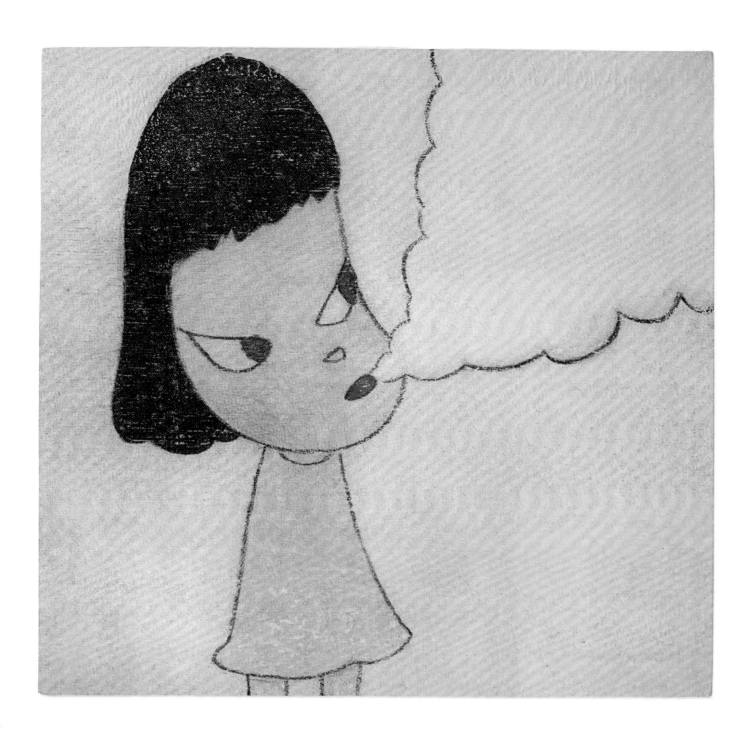

YOSHITOMO NARA
music: The Busy Signals
title: Pretend Hits
LP
US. 2001

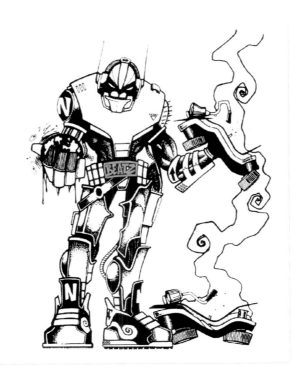

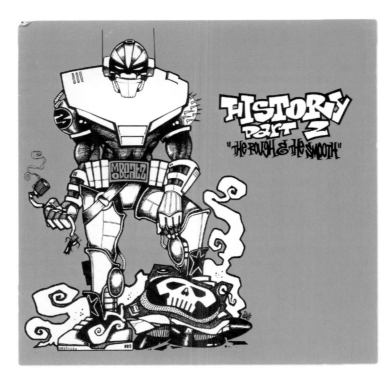

DAVE NODZ
music: DJ DB
title: The History Of Our World Part 1: Breakbeat & Jungle Ultramix
CD
US. 1994

DAVE NODZ
music: DJ DB
title: History Part 2: The Rough & The Smooth
CD
US. 1996

SIMON NORFOLK
music: The Nels Cline Singers
title: Initiate
2 × CD
US. 2010

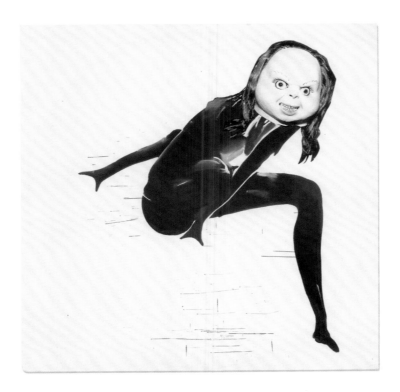

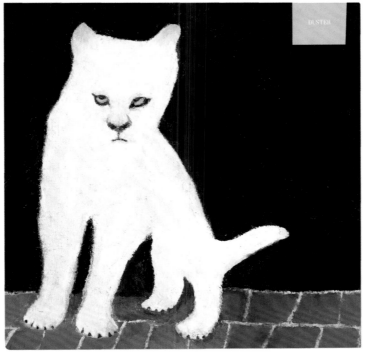

ALBERT OEHLEN
music: Child Abuse
title: Child Abuse
LP
US. 2007

ALBERT OEHLEN
music: Duster
title: Duster
LP, pink vinyl
US. 2019. Edition of 500

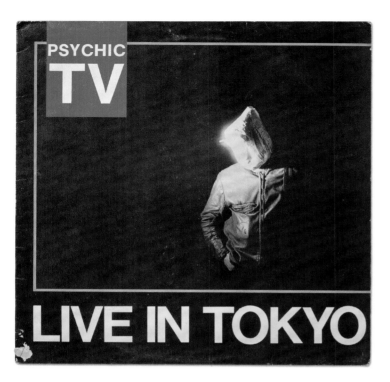

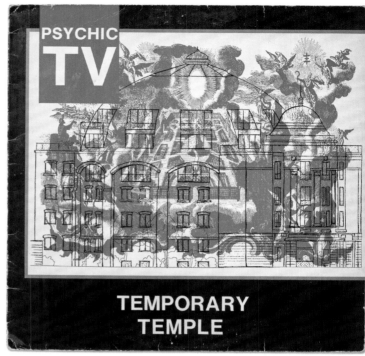

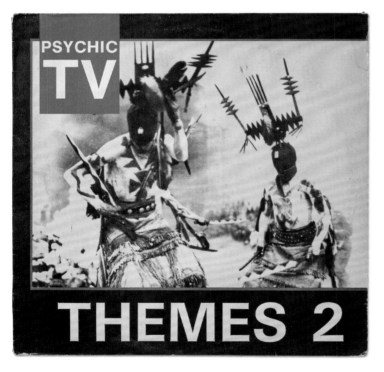

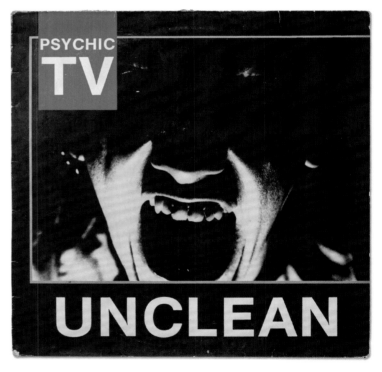

GENESIS P-ORRIDGE
music: Psychic TV
title: Live in Tokyo
LP
UK. 1986. Edition of 5,000

GENESIS P-ORRIDGE
music: Temporary Temple
title: Live in Tokyo
LP
UK. 1987. Edition of 2,300

GENESIS P-ORRIDGE
music: Psychic TV
title: Themes 3
LP
UK. 1987

GENESIS P-ORRIDGE
music: Unclean
title: Live in Tokyo
12"
UK. 1984

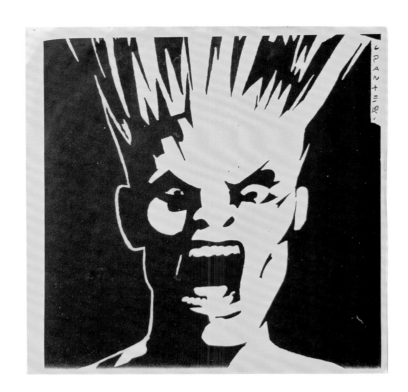

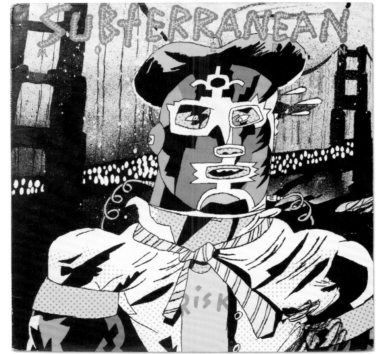

GARY PANTER
music: Screamers
title: Demos 1977 Volume One
7"
US. 1996

GARY PANTER
music: Various
title: Subterranean Modern
LP
US. 1983 reissue. Edition of 2,500

PAPER RAD
music: Paper Rad
title: Paper Rad Uniform
7", screen printed + trading cards (cover + small cards)
US. 2006. Edition of 500

PAPER RAD
music: Kurt Weisman
title: More is More
7"
US. 2006

143

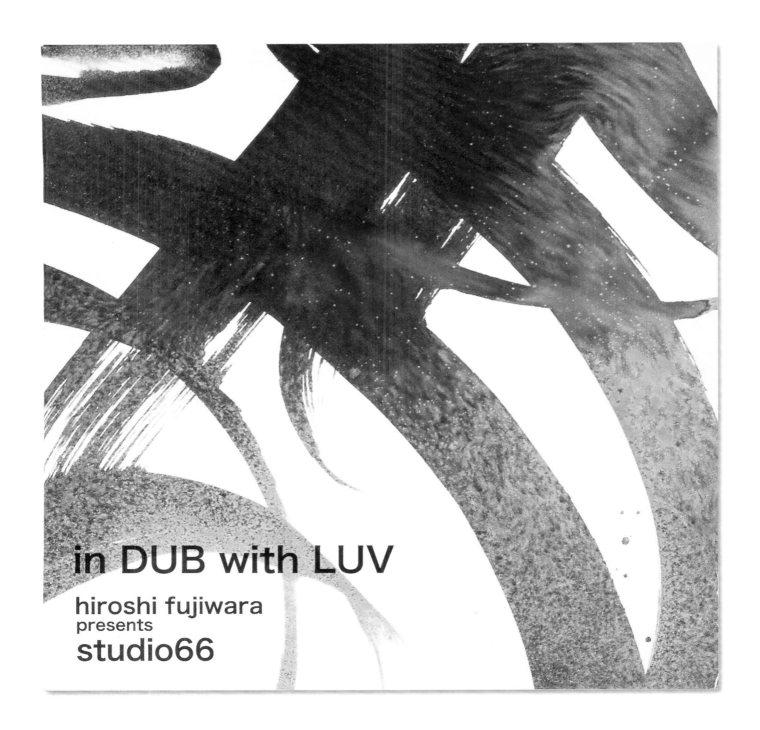

in DUB with LUV

hiroshi fujiwara
presents
studio66

JOSÉ PARLÁ
music: Hiroshi Fujiwara Presents Studio66
title: In Dub With Luv
CD
Japan. 2010

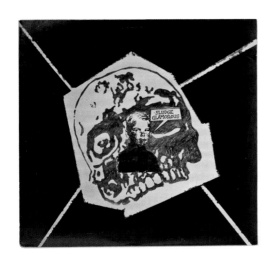

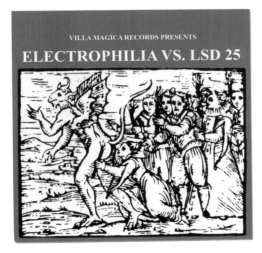

STEVEN PARRINO
music: Melvins
title: Sludge Glamorous
12", gray marbled vinyl
US. 2010. Edition of 2,000

STEVEN PARRINO
music: Steven Parrino and Friends
title: Electrophilia VS. LSD 25
CD single
Switzerland. 1998

OLIVER PAYNE / NICK RELPH
music: Brian Degraw
title: Sonic the Warhol
LP
US. Date unknown. Edition of 500

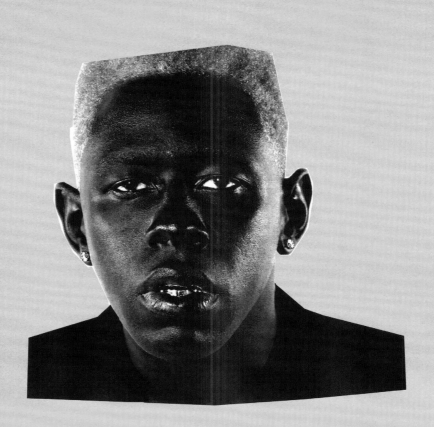

ALL SONGS WRITTEN, PRODUCED AND ARRANGED BY
TYLER OKONMA

LUIS PANCH PEREZ
music: Tyler, the Creator
title: Igor
LP
US. 2019

SIMON PERITON
music: Goldfrapp
title: Lovely Head
12"
UK. 2000

ROBERT POLLARD
music: Big Dipper
title: Joke Outfit / Market Scare
7"
US. 2013. Edition of 500

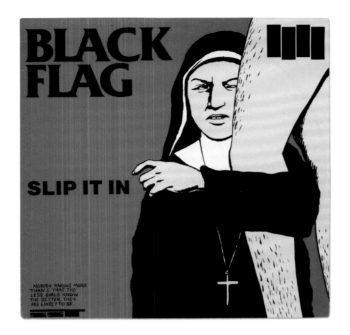

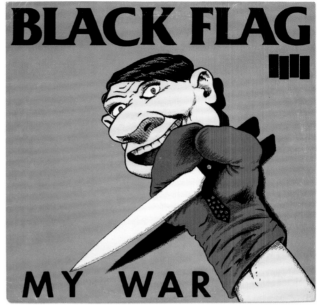

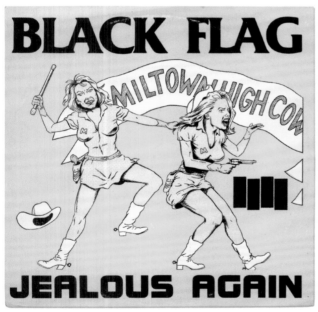

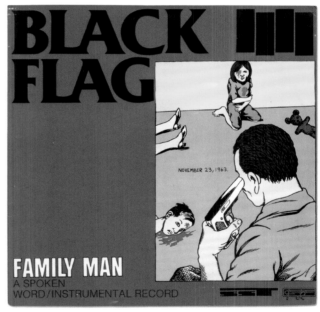

RAYMOND PETTIBON
music: Black Flag
title: Slip It In
LP
US. 1984

RAYMOND PETTIBON
music: Black Flag
title: Jealous Again
12" EP
US. 1980

RAYMOND PETTIBON
music: Black Flag
title: My War
LP
US. 1984

RAYMOND PETTIBON
music: Black Flag
title: Family Man
LP
US. 1984

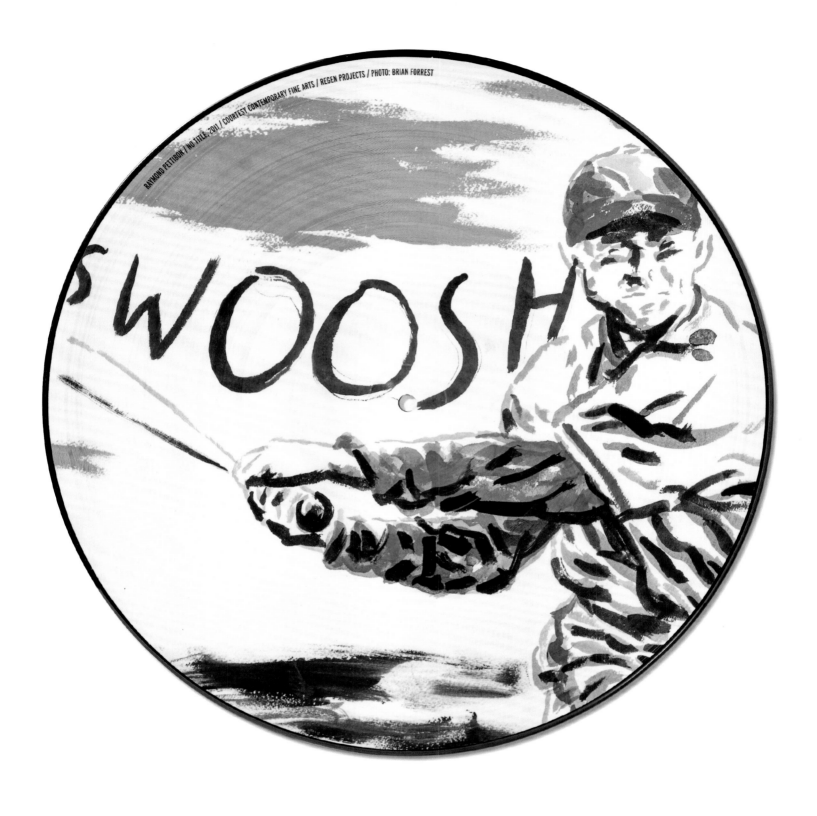

RAYMOND PETTIBON
music: Raymond Pettibon & Oliver Augst
title: Burma Shave Electrics
12" picture disc
Germany. 2013. Edition of 25 signed

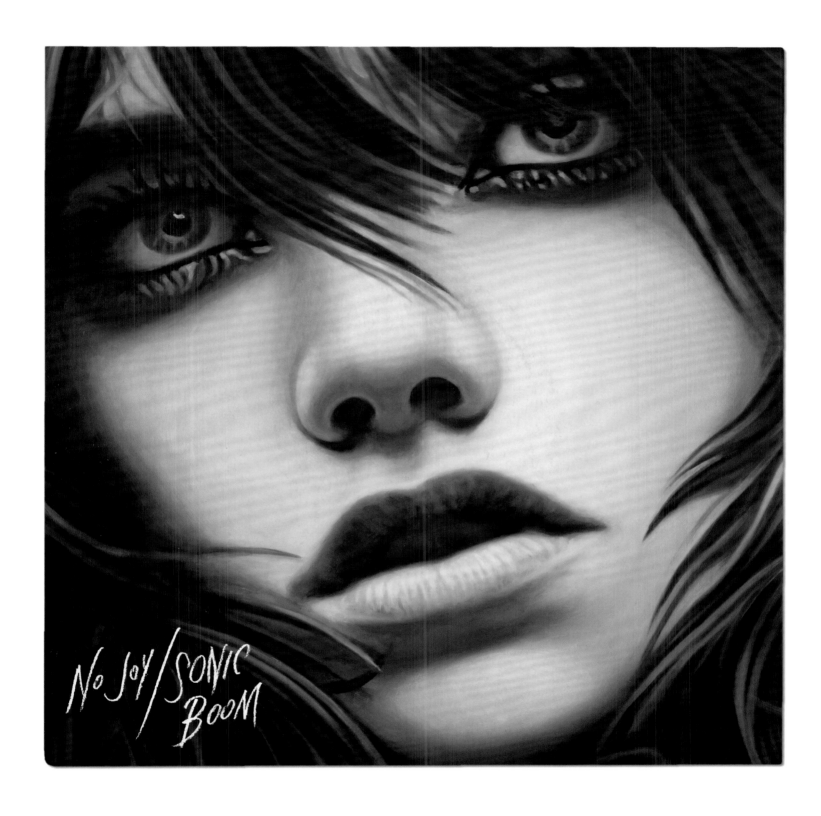

RICHARD PHILLIPS
music: No Joy / Sonic Boom
title: No Joy / Sonic Boom
12" EP, green and pink vinyl
UK / Europe / US. 2018. Edition of 300 numbered

RICHARD PHILLIPS
music: Dirty Vegas
title: Ghosts
12"
UK. 2002

RICHARD PHILLIPS
music: Dirty Vegas
title: Dirty Vegas
2 × LP
UK. 2002

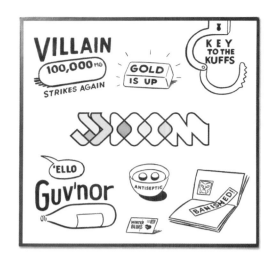

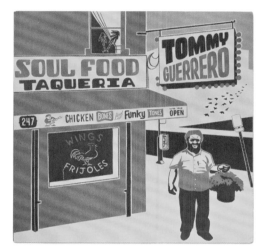

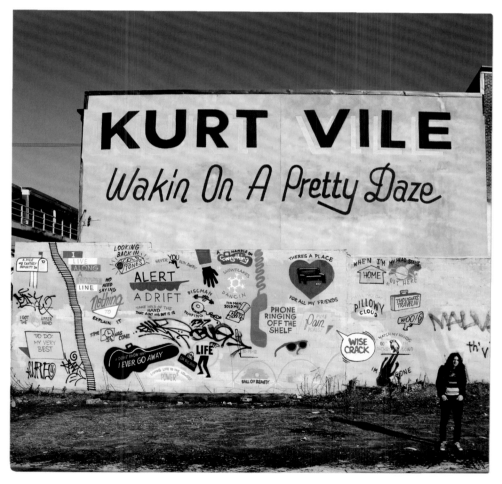

STEVE POWERS
music: JJ Doom
title: Key to the Kuffs
2 × LP
UK / Europe. 2012

STEVE POWERS
music: Tommy Guerrero
title: Soul Food Taqueria
LP
UK. 2003

STEVE POWERS
music: Kurt Vile
title: Wakin on a Pretty Daze
2 × LP
US. 2013

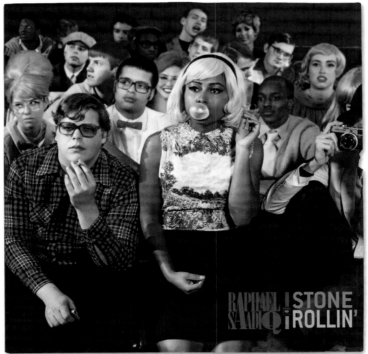

ROY PORELLO / LESLIE DAVIS
music: The Rapture
title: In The Grace Of Your Love
2 × LP, blue vinyl
US. 2011. Edition of 1,000

ALEX PRAGER
music: Raphael Saadiq
title: Stone Rollin'
LP
US. 2011

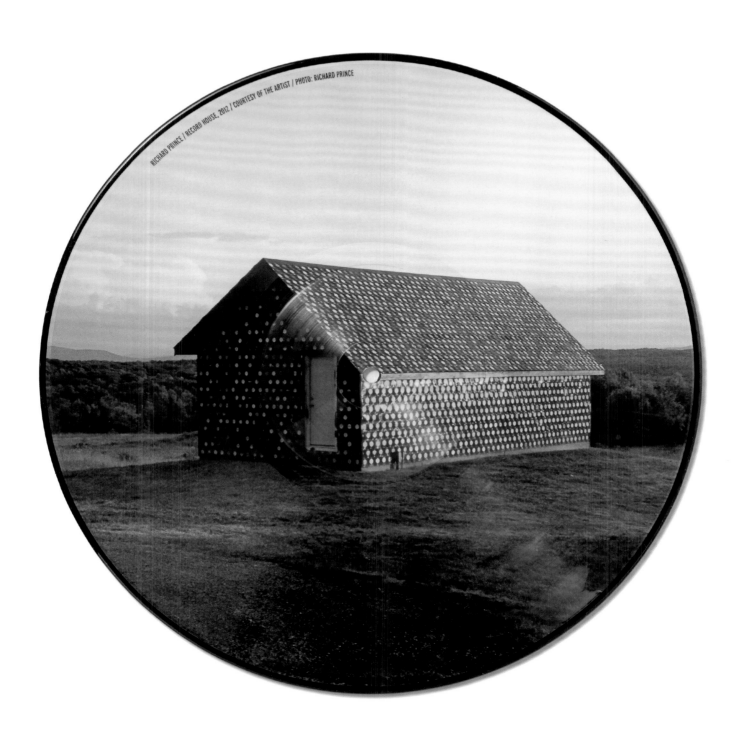

RICHARD PRINCE, RECORD HOUSE, 2012 / COURTESY OF THE ARTIST / PHOTO: RICHARD PRINCE

RICHARD PRINCE
music: Richard Prince
title: It's a Free Concert Now
LP, single-sided picture disc
Germany. 2015. Edition of 25 signed + numbered

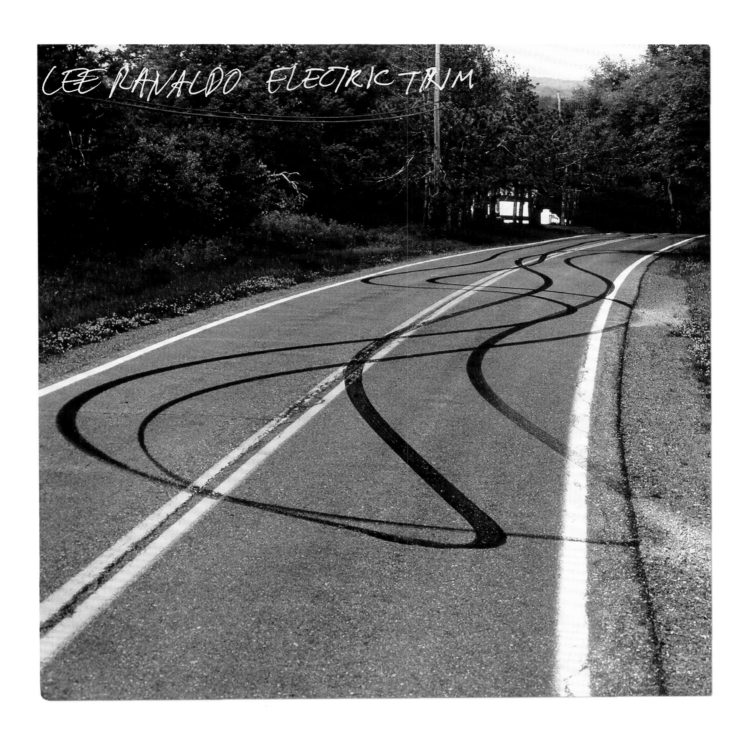

RICHARD PRINCE
music: Lee Ranaldo
title: Electric Trim
2 × LP
US / Canada / Europe. 2017

PUSHEAD
music: Various
title: Pusmort Sampler
7" compilation
US. 1987

PUSHEAD
music: 16
title: Felicia
7"
US. 1994

PUSHEAD
music: Saigan Terror / Stompede
title: Saigan Terror / Stompede
7" white vinyl + 7" green vinyl
US. 2001. Edition size unknown

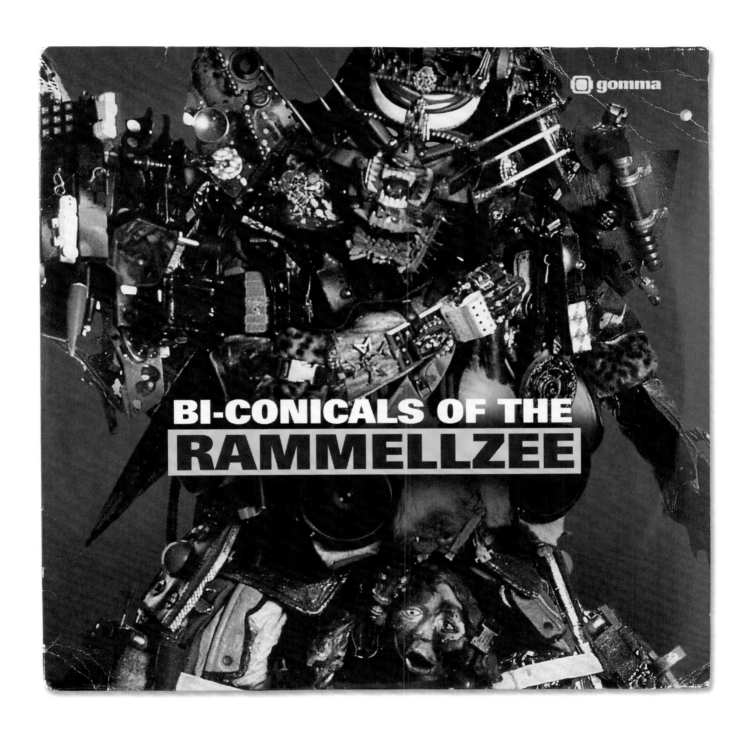

RAMMELLZEE
music: Rammellzee
title: Bi-Conicals Of The Rammellzee
2 × LP
Germany. 2004

KEITH RANKIN
music: Guerilla Toss
title: Eraser Stargazer
LP (front + back cover + inner sleeve)
US. 2016

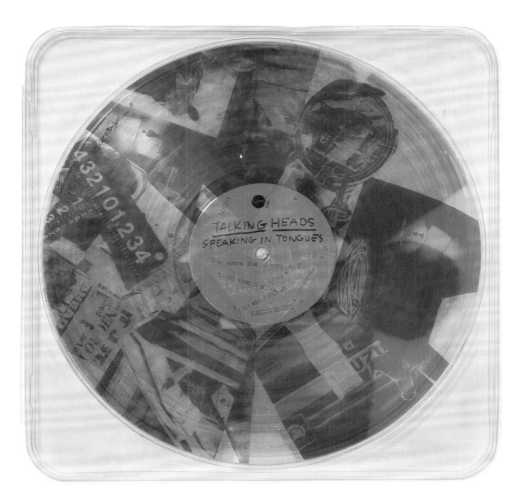

CHARLES RAY
music: Van Dyke Parks
title: Hold Back Time / Amazing Graces
7"
US. 2011

ROBERT RAUSCHENBERG
music: Talking Heads
title: Speaking In Tongues
LP, clear vinyl (artwork + credits printed on clear plastic discs)
US. 1983. Edition of 50,000

TOBIAS REHBERGER
music: Blank
title: Duden
LP
Germany. 2004

TOBIAS REHBERGER
music: Daniel Haaksman
title: African Fabrics
CD
Germany. 2016

GERHARD RICHTER
music: Tarotplane
title: 358 Oblique
LP
Netherlands. 2017. Edition of 300

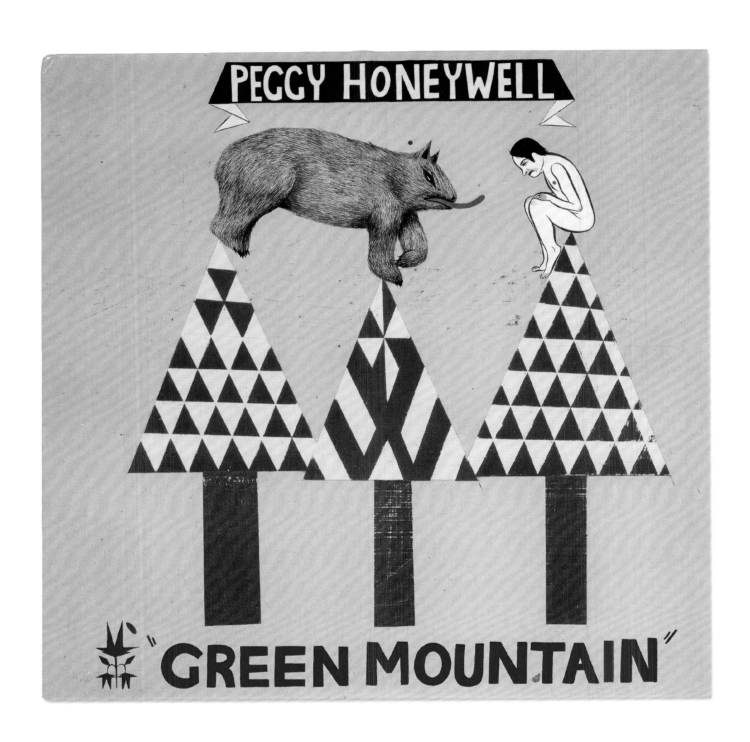

CLARE E ROJAS
music: Peggy Honeywell
title: Green Mountain
7"
US. 2006

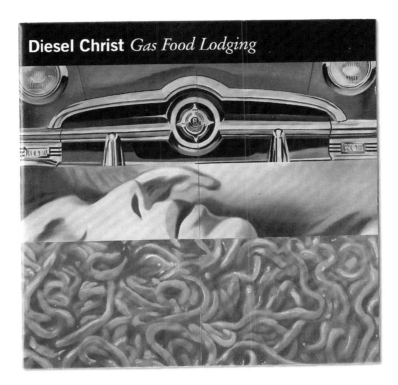

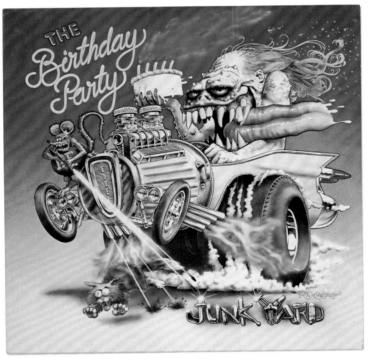

JAMES ROSENQUIST
music: Diesel Christ
title: Gas Food Lodging
CD
Germany. 1993

ED ROTH
music: The Birthday Party
title: Junkyard
LP
Australia. 1982

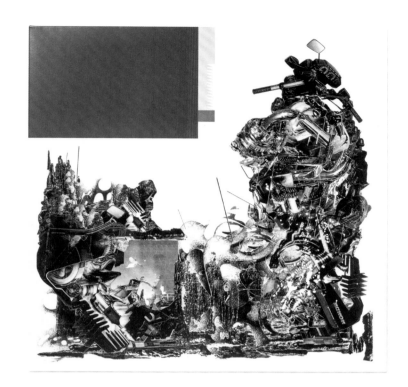

DAVID RUDNICK
music: Black Midi
title: Schlagenheim
LP
UK / US. 2019

DAVID RUDNICK / ONEOHTRIX POINT NEVER
FEATURING ARTWORK BY JIM SHAW
music: Oneohtrix Point Never
title: Age Of
LP, translucent neon-yellow vinyl
UK. 2018. Edition of 750

ED RUSCHA
music: David Greenberger & Prime Lens
title: It Happened To Me
LP
US. 2019. Edition size unknown

ED RUSCHA
music: Geoff Muldaur And The Texas Sheiks
title: Texas Sheiks
LP
Germany. 2009

A.09 TABLE

ED RUSCHA
music: Nels Cline
title: Dirty Baby
2 × CD box-set + 2 booklets (interior booklet)
US. 2010

ED RUSCHA
music: Nels Cline
title: Dirty Baby
2 × CD box set + 2 booklets (front cover + back cover)
US. 2010

ED RUSCHA
music: Nels Cline
title: Dirty Baby
2 × CD box-set + 2 booklets (interior booklet)
US. 2010

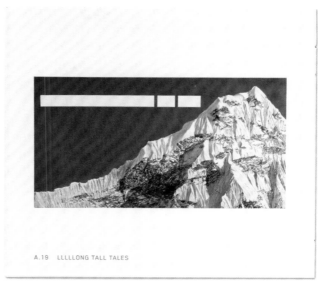

A.19 LLLLLONG TALL TALES

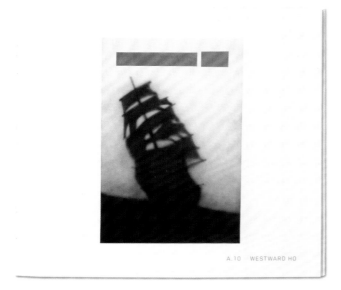

A.10 WESTWARD HO

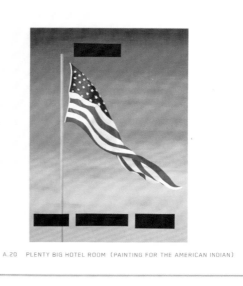

A.20 PLENTY BIG HOTEL ROOM (PAINTING FOR THE AMERICAN INDIAN)

ED RUSCHA
music: Nels Cline
title: Dirty Baby
2 × CD box-set + 2 booklets (interior booklet)
US. 2010

ED RUSCHA
music: Nels Cline
title: Dirty Baby
2 × CD box-set + 2 booklets (interior booklet)
US. 2010

ED RUSCHA
music: Nels Cline
title: Dirty Baby
2 × CD box-set + 2 booklets (interior booklet)
US. 2010

ED RUSCHA
music: Nels Cline
title: Dirty Baby
2 × CD box-set + 2 booklets (interior booklet)
US. 2010

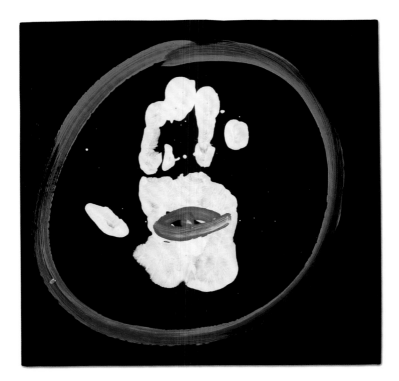

RICHARD RUSSELL, LEE "SCRATCH" PERRY
music: Residence La Revolution
title: I Am Paint
12"
UK. 2015. Edition of 250

MARK RYDEN
music: Various
title: Alright, This Time, Just The Girls
2 × LP compilation, pink marbled vinyl
US. 1999. Edition size unknown

MARK SALWOWSKI / BETH HALL
music: Alex Barnett
title: Chew From The Mind
12"
US. 2016

MARK SALWOWSKI / BETH HALL
music: HIDE
title: Flesh For The Living
12" EP
US. 2016

MARK SALWOWSKI / BETH HALL
music: Viands
title: Temporal Relics
LP
US. 2015

PETER SAVILLE / TREVOR KEY
music: New Order
title: Blue Monday
12"
UK. 1983

PETER SAVILLE / BEN KELLY
music: Orchestral Manoeuvres in the Dark
title: Orchestral Manoeuvres In The Dark
LP
UK. 1980

PETER SAVILLE AFTER FORTUNATO DEPERO
music: New Order
title: Everything's Gone Green / Procession
7"
UK. 1981

PETER SAVILLE / BRETT WICKENS
music: Orchestral Manoeuvres in the Dark
title: Architecture & Morality
LP
UK. 1981

PETER SAVILLE / TREVOR KEY
music: New Order
title: Technique
LP
UK. 1989

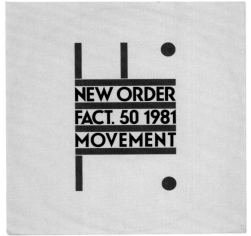

PETER SAVILLE AFTER FORTUNATO DEPERO
music: New Order
title: Movement
LP
UK. 1981

PETER SAVILLE AFTER FANTIN-LATOUR
music: New Order
title: Power, Corruption & Lies
LP
UK. 1983

PETER SAVILLE / TREVOR KEY
music: New Order
title: True Faith
LP
UK. 1987

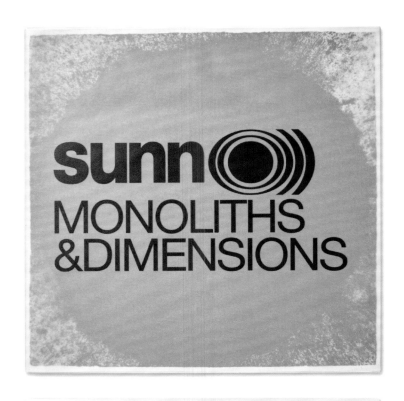

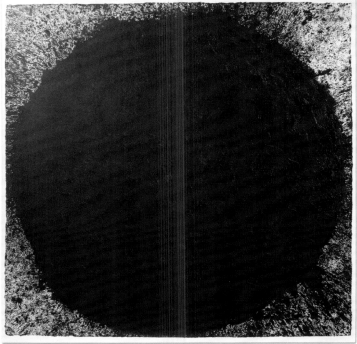

RICHARD SERRA
music: Sunn O)))
title: Monoliths & Dimensions
2 × LP (front cover + interior image)
US. 2009

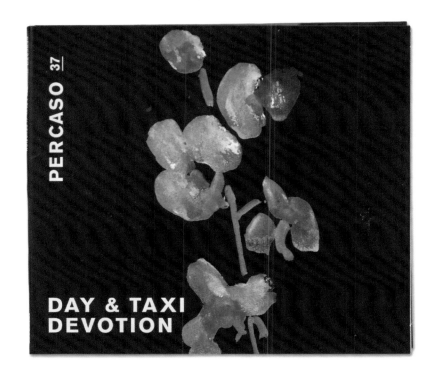

THOMAS SCHÜTTE
music: Day & Taxi
title: Devotion
CD
Switzerland. 2019

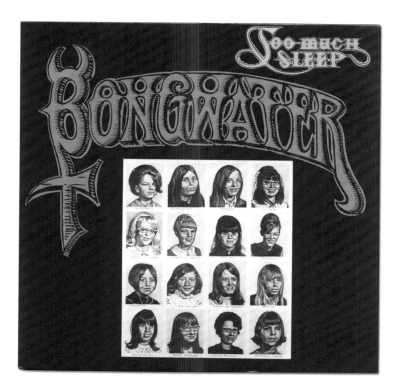

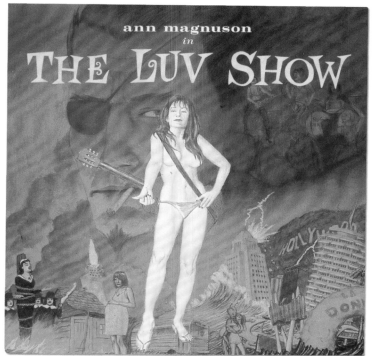

JIM SHAW
music: Bongwater
title: Too Much Sleep
LP
US. 1989

JIM SHAW
music: Ann Magnuson
title: The Luv Show
CD
Europe. 1995

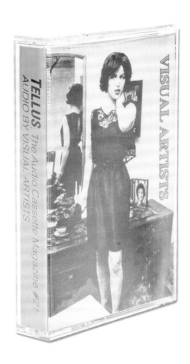

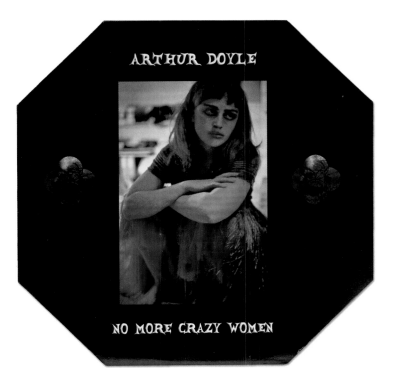

CINDY SHERMAN
music: Various
title: Audio By Visual Artists
Cassette compilation
US. 1988. Edition of 1,000

CINDY SHERMAN
music: Arthur Doyle
title: No More Crazy Women
12"
Italy. 2005

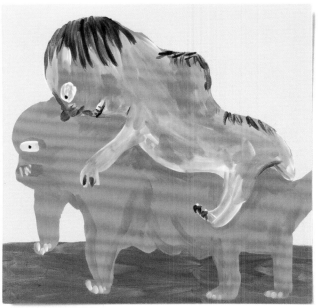
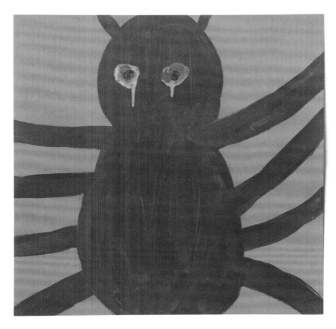
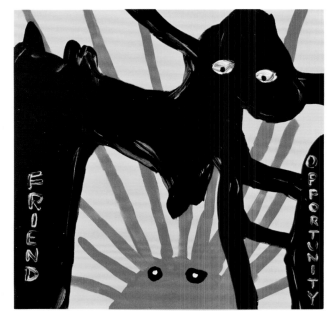

DAVID SHRIGLEY
music: Deerhoof
title: Friend Opportunity
LP (loose interior artworks)
US. 2007

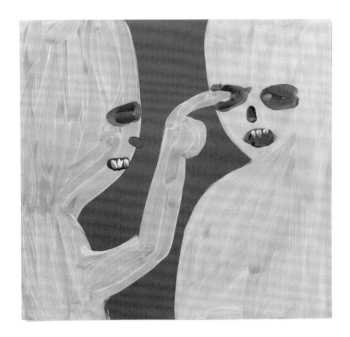

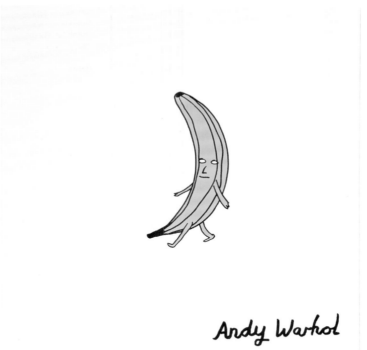

DAVID SHRIGLEY
music: Stephen Malkmus and Friends
title: Can's Ege Bamyasi
LP
US. 2013. Edition of 1,000

DAVID SHRIGLEY
music: Various
title: The Velvet Underground & Nico
LP compilation
US. 2012

DAVID SHRIGLEY
music: White Night
title: White Night
7" EP picture disc
UK. 2008

DAVID SHRIGLEY
music: Deerhoof
title: Seeks Maniac / Makko Shobu Matchbook
7" picture disc
US. 2007

SHITKID / MILKDROP STUDIO
music: ShitKid
title: Duo Limbo / "Mellan himmel å helvete"
LP, black, red and white tri-color vinyl
US. 2020. Edition of 100

SHITKID / MOA ROMANOVA
music: ShitKid
title: Fish
LP
Sweden. 2017

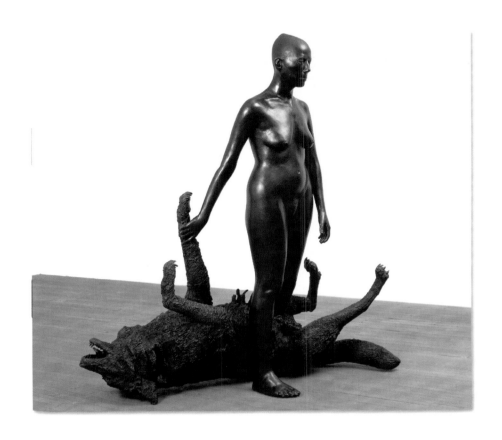

KIKI SMITH
music: John Zorn
title: Femina
CD + booklet (interior image)
US. 2009

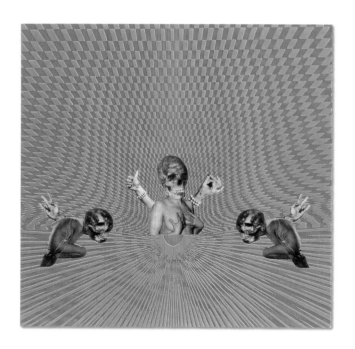

DASH SNOW
music: Rub N Tug
title: Better With A Spoonful Of Leather aNYthing Mix Volume 2
CD compilation (interior image)
US. 2006

ALEC SOTH
music: Dolorean
title: The Unfazed
LP, translucent root-beer colored vinyl
US. 2011. Edition of 150

STANDING ON THE CORNER
music: Standing on the Corner
title: Standing on the Corner
LP
US. 2017. Edition of 70

MATTHEW STONE
music: FKA Twigs
title: M3LL155X
12" EP (inner sleeve)
UK. 2015

DEVIN TROY STROTHER
music: Zackey Force Funk
title: Electron Don
LP
Czech Republic. 2016. Edition of 300

JUN TAKAHASHI
music: Can
title: Future Days
12"
Japan. 2017

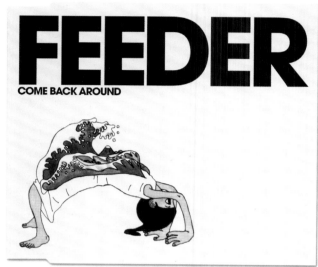

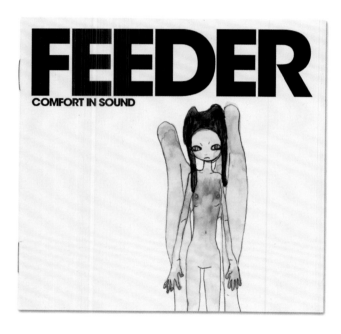

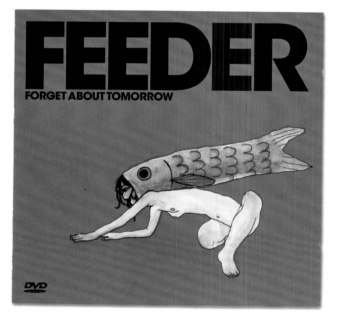

AYA TAKANO
music: Feeder
title: Just The Way I'm Feeling
CD
US / EU / Japan. 2003

AYA TAKANO
music: Feeder
title: Comfort In Sound
CD
US / EU / Japan. 2002

AYA TAKANO
music: Feeder
title: Come Back Around
CD
US / EU / Japan. 2002

AYA TAKANO
music: Feeder
title: Forget About Tomorrow
CD
US / EU / Japan. 2003

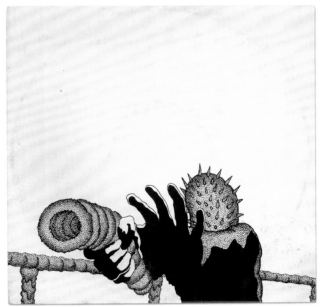

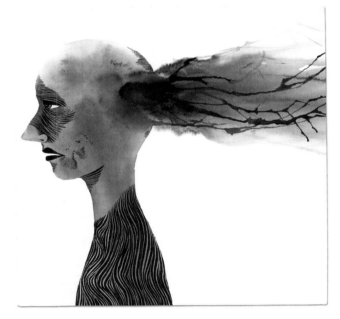

MEGAN TATEM
music: Various
title: 7-inches for Planned Parenthood
10 × 7" pink vinyl box set
US. 2017

JUERGEN TELLER
music: Cocteau Twins
title: Blue Bell Knoll
LP
UK. 1988. Edition size unknown

TETSUNORI TAWARAYA
music: Thee Oh Sees
title: Mutilator Defeated At Last
LP
US. 2015

ED TEMPLETON
music: Claus Grabke
title: Deadly Bossanova
CD (detail)
Europe. 2008

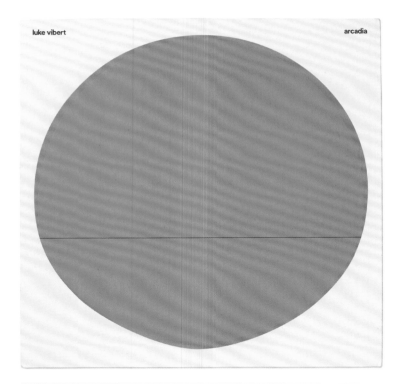

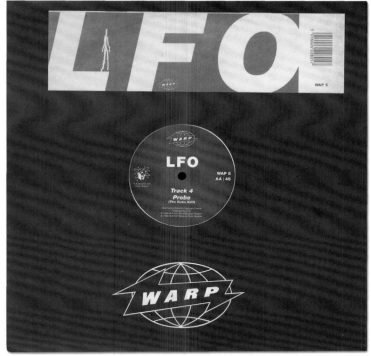

THE DESIGNERS REPUBLIC
music: Luke Vibert
title: Arcadia
12" EP
Belgium. 2018

THE DESIGNERS REPUBLIC
music: LFO
title: LFO
12"
UK. 1990

190

THE DESIGNERS REPUBLIC / WEIRDCORE
music: Aphex Twin
title: Collapse EP
12"
UK / EU / US. 1990

WOLFGANG TILLMANS
music: Wolfgang Tillmans
title: Device Control EP
12" EP
Germany. 2016

WOLFGANG TILLMANS
music: Wolfgang Tillmans
title: 2016 / 1986 EP
12" EP
Germany. 2016

WOLFGANG TILLMANS
music: Tiga
title: 3 Weeks
12"
Belgium. 2006

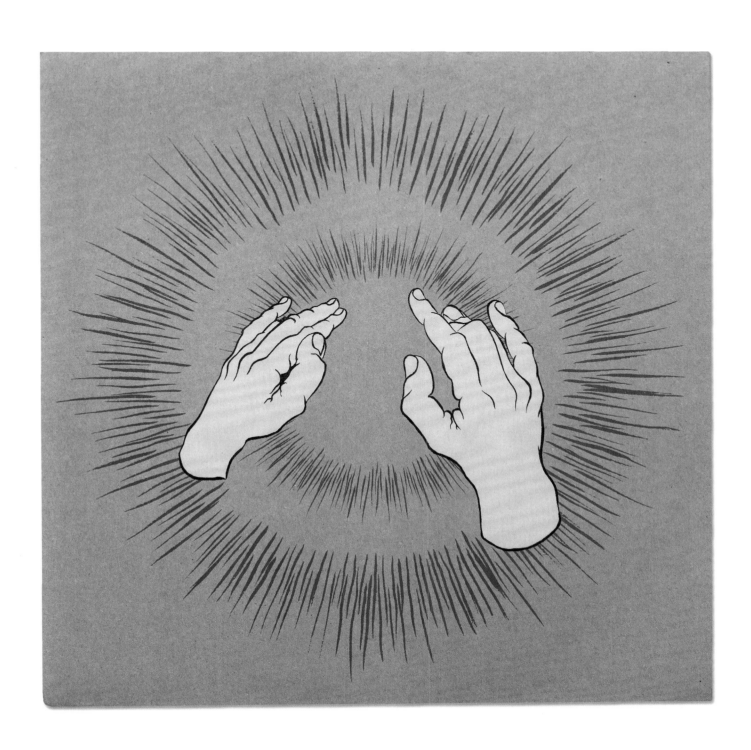

JOHN ARTHUR TINHOLT
Inspired by Will Schaff
music: Godspeed You Black Emperor!
title: Lift Your Skinny Fists Like Antennas To Heaven
2 × LP
Canada. 2000

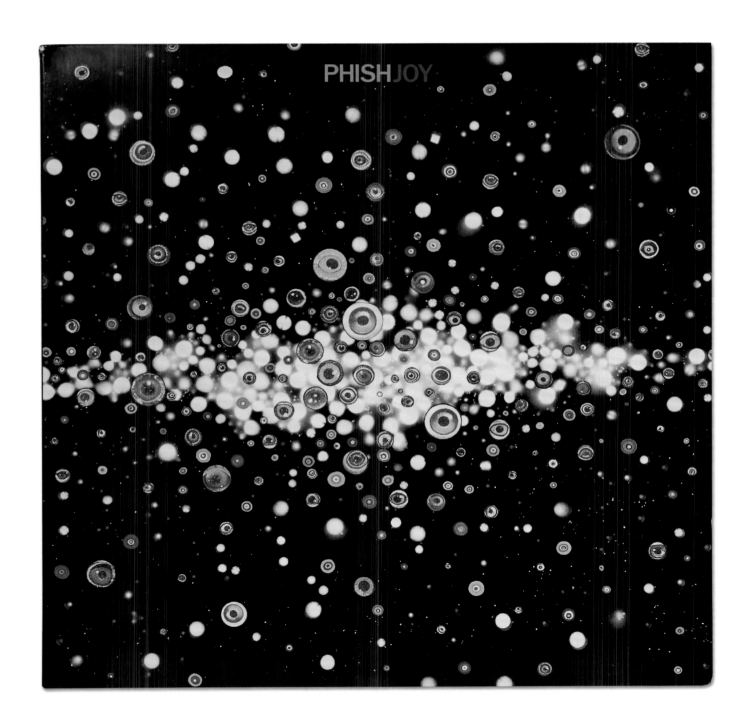

FRED TOMASELLI
music: Phish
title: Joy
LP, single-sided etched
US. 2009

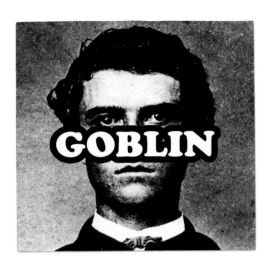

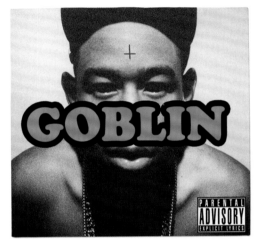

TYLER, THE CREATOR / MATT DEJONG
music: Tyler, The Creator
title: Goblin
2 × LP
US. 2011

INEZ VAN LAMSWEERDE / VINOODH MATADIN
music: Björk
title: Vulnicura
2 × LP (interior image)
UK / Europe / US. 2015. Edition of 5,000

ALAN VEGA
music: Alan Vega
title: Station
CD
US. 2007

XAVIER VEILHAN
music: Air
title: Pocket Symphony
2 × LP, white vinyl
Europe. 2007

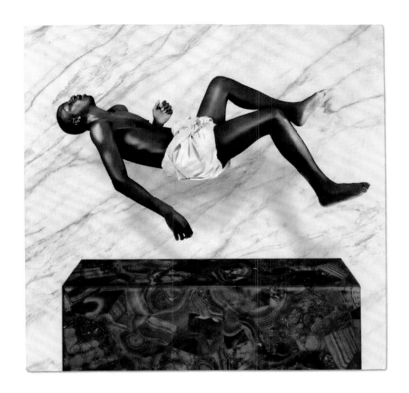

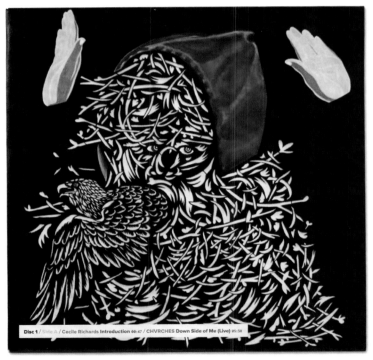

LINA VIKTOR / ROCHELLE NEMBHARD
music: Petite Noir
title: La Vie Est Belle / Life Is Beautiful
LP, single-sided
Europe. 2015

WILLIAM VILLALONGO
music: Various
title: 7-inches for Planned Parenthood
10 × 7", pink vinyl box set
US. 2017

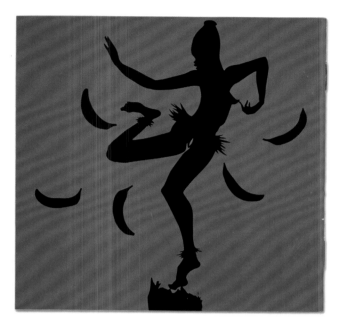
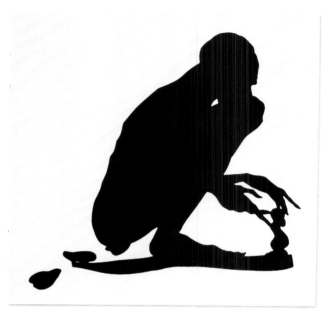
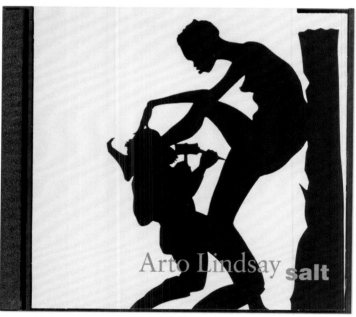
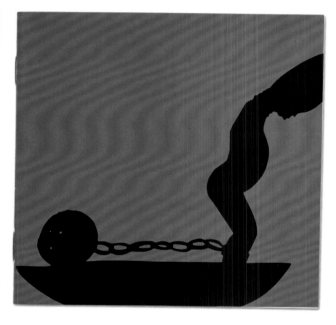

Arto Lindsay **salt**

KARA WALKER
music: Arto Lindsay
title: Salt (front cover + interior images)
CD
US / Europe. 2004

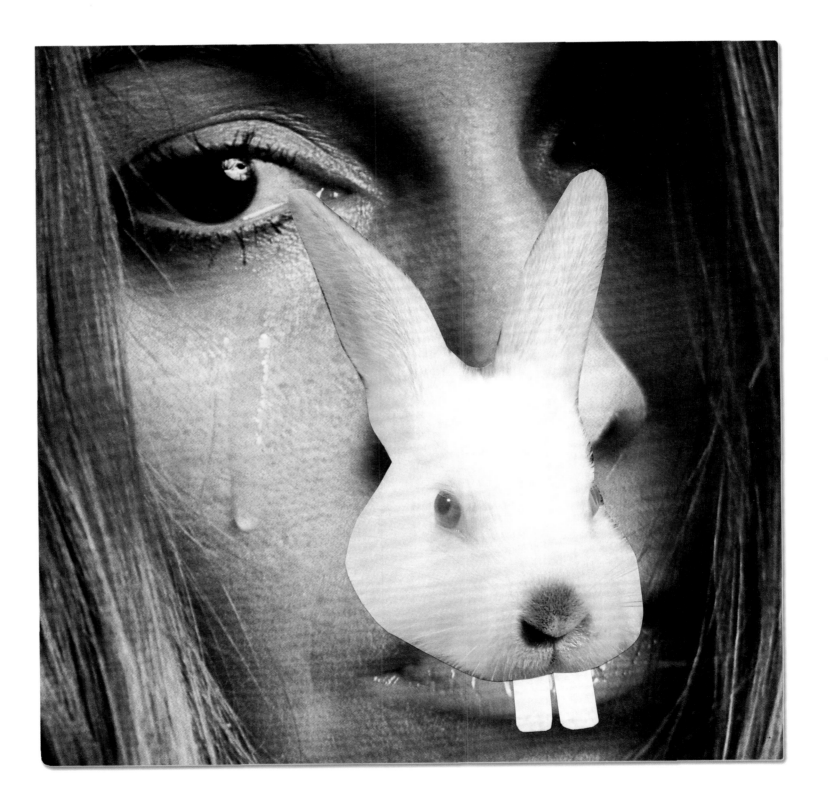

MARNIE WEBER
music: Natalie Sandtorv
title: Pieces of Solitude
LP
Norway. 2015. Edition of 300

LAWRENCE WEINER
music: Thick Pigeon
title: Too Crazy Cowboys
LP
UK. 1984

LAWRENCE WEINER
music: Ned Sublette, Lawrence Weiner & The Persuasions
title: Ships At Sea, Sailors & Shoes
CD
US / UK. 1993

LAWRENCE WEINER
music: Various
title: Of Factory New York
2 × LP compilation
Europe. 2014

LAWRENCE WEINER
music: Peter Gordon, Lawrence Weiner
title: Deutsche Angst
7"
Belgium. 1982

LAWRENCE WEINER
music: Love of Life Orchestra
title: Geneva
LP
US. 1980

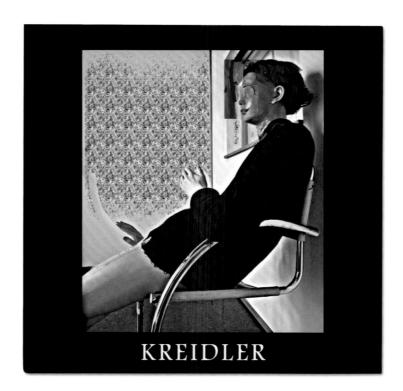

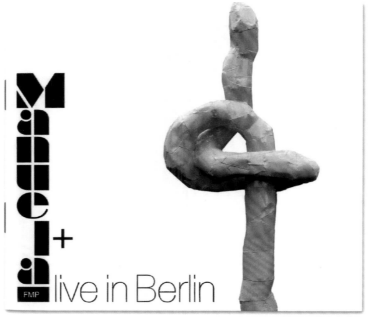

ANDRO WEKUA
music: Kreidler
title: Tank
LP
Germany. 2011

FRANZ WEST
music: Manuela+
title: Live in Berlin
CD
Germany. 2011

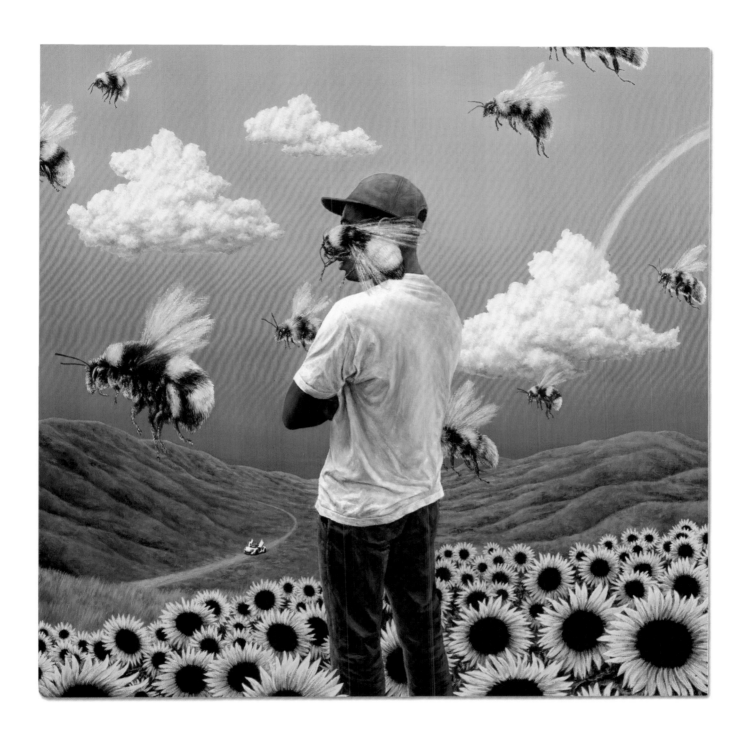

ERIC WHITE
music: Tyler, The Creator
title: Flower Boy
2 × LP
US. 2017

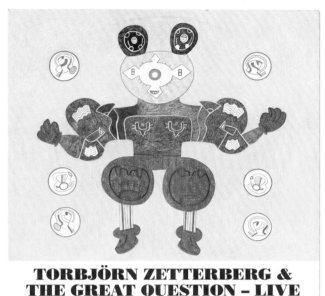

**TORBJÖRN ZETTERBERG &
THE GREAT QUESTION – LIVE**

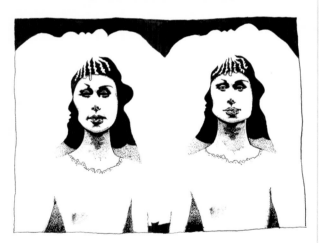

NUCLEAR FAMILY

JOE MCPHEE & ANDRÉ JAUME

KARL WIRSUM
music: Torbjörn Zetterberg & The Great Question
title: Live
CD
US. 2019

KARL WIRSUM
music: Joe McPhee & André Jaume
title: Nuclear Family
CD
US. 2016

DAVID WOJNAROWICZ
music: 3 Teens Kill 4
title: No Motive
LP
US. 1983

DAVID WOJNAROWICZ
music: Bob Ostertag
title: Burns Like Fire
CD
Switzerland. 1992

DAVID WOJNAROWICZ
music: Black Snakes
title: Crawl (label)
7"
Sweden. 1988. Edition of 1,000

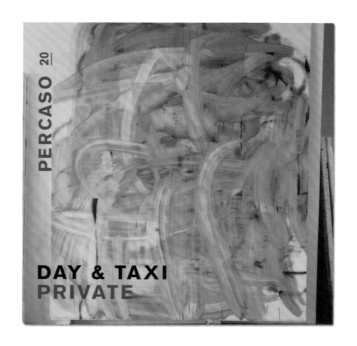

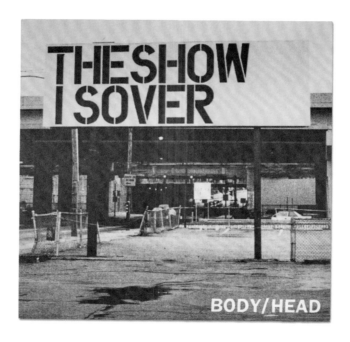

CHRISTOPHER WOOL
music: Day & Taxi
title: Private
CD
Switzerland. 2003

CHRISTOPHER WOOL
music: Body/Head
title: The Show Is Over
7"
US. 2014

ANDREW JEFFREY WRIGHT
music: Black Lips / Yacht
title: Wild Man / No Favors Policy
7"
US. 2007

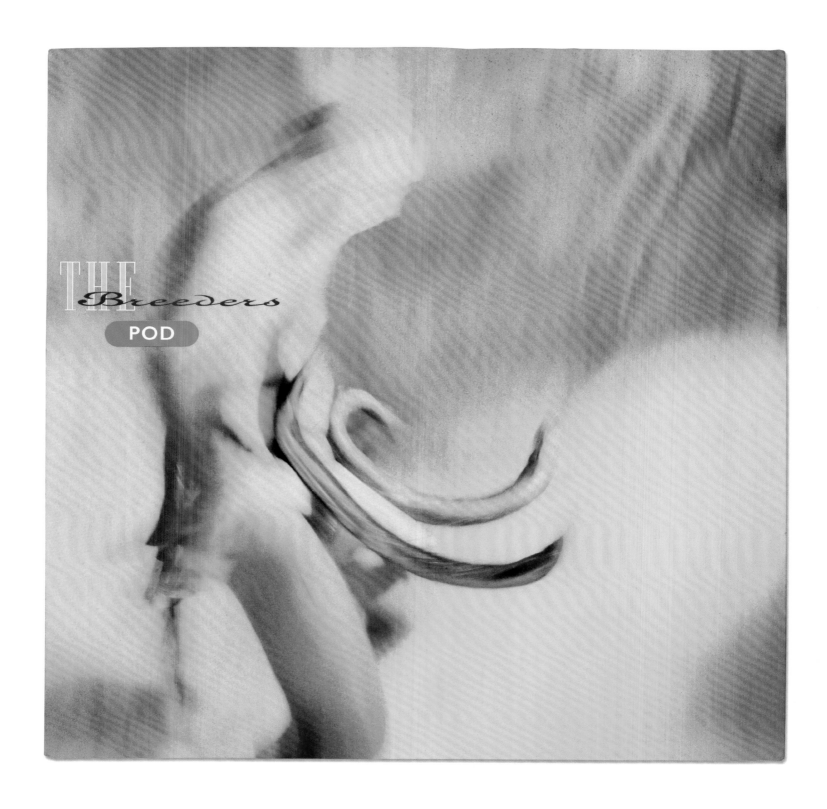

THE *Breeders*
POD

23ENVELOPE
concept + photography: Nigel Grierson
design: Vaughan Oliver
artist: The Breeders
title: Pod
LP. UK. 1990

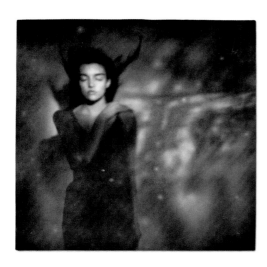

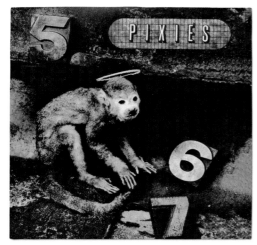

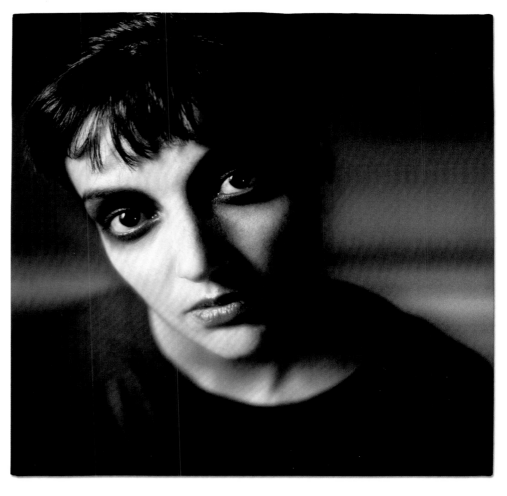

23ENVELOPE
concept + photography: Nigel Grierson
design: Vaughan Oliver
artist: This Mortal Coil
title: It'll End In Tears
LP. UK. 1984

23ENVELOPE
concept + photography: Nigel Grierson
design: Vaughan Oliver
artist: Pixies
title: Monkey Gone To Heaven
12". UK. 1989

23ENVELOPE
concept + photography: Nigel Grierson
design: Vaughan Oliver
artist: This Mortal Coil
title: Blood
2 × LP. UK. 1991

Thank you

Anne Hoffmann
Anneliis Beadnell
Arne Gesemann
Becky Bick
Ben Blackwell
Beth Hall
Bjorn Copeland
Bradley Bledsoe
Brandon Minow
Brenda Guesnet
Brian at *Chaikin Records*
Brian Foley
Bridget Donahue
Bryan Ray Turcotte
Bryce Edge
Caitlin Pasko
Cali Thornhill DeWitt
Callender DeMont
Carly James
Carol Parkinson
Caroline Burghardt
Carsten Nicolai
Cary at *Book Beat*
Chelsea Hadley
Chris Hufford
Christian Clancy
Christian Egger
Christoph Gallio
Claire Rifelj
Craig Mathis at *Printed Matter*
Crystal Baxley
Dan at *Jeff Wall Studio*
Daniel at *Marnie Weber Studio*
Daniel Horitz
Dave Betts at *Columbia Records*
Dave Kaplan
David Ellis
David Marek
David Spero
Dean O'Connor
Denise Melanson
Dennis Kane
Dick Johnston
Dieter Kern
Don at *Constellation Records*
Doug Cunningham
Douglas J. Mackinlay
Edward O'Dowd
Eik Meyer
Elizabeth Lamere
Erik Foss
Eugene Whang
Eva Badura
Fabiola Alondra
Fatima Al Qadiri
Fred Tomaselli
Gary Walker at *30th Century Records*
Geoff Harrison
Gordon, Cyrus & Eric at *Mississippi Records*
Grant Manship
Grant Schofield & *Karma Gallery*
Gunther Buskies
Harry Wright
Hector Martinez
Heung-Heung Chin
HLF / PIN
HOAX
Homer Flynn
Iain Scott

Ilene Roth
Irina Stark
Jackie at *Rammellzee Estate*
Jacqueline Simon
Jade Berreau
James Endeacott
James Nice
Jamie Russell
Jane Harmon
Jared Rosenberg
Jason Cori
Javier Peres
Jay Moss
Jay Schumer at *Sony*
Jeff Gauthier
Jeff Heavenly
Jeff Jank
Jeff Newman
Jeffrey Deitch
Jen Cox
Jennifer Belt
Jennifer Hall
Jeroen Wille
Jesse Sanes & HOAX
Jessica Fredericks
Jim Drain
Jim Magas
João Santos
Joe Rosenberg
Joern at *BQ*
John Bertram
John Bongiorno
John Corbett
John Zorn
Jon Mason
Jonathan Galkin
Jonathan Levine Projects
Jorg at *Anne Hoffmann Graphic Design*
Jörg Hiller
Josh Hymowitz
Josie Keefe
Judith Stoeckl
Julia Klose at *Verlag Klaus Wagenbach*
Julie Calland
Julie Hagen Kongsted
Julius Steinhoff
Kate Pollasch
Kathy Grayson
Keith Abrahamsson
Kelsey Tyler
Kensuke Hara
Kevin Hsieh
Kim Pollock
Konstanze Ell
Kool Koor
Kristian at *Fysisk Format*
Lara at *Elizabeth Peyton Studio*
Lauran Rothstein
Lexi Campbell
Lily Spitz
Lily Walters
Lisa Ziven
Lori Feldman
Lotte at *Lisson Gallery*
Lucas Page
Luis Panch Perez
Lynsey Scott
Marc Alain
Marc Picken

Marcel & Karl at *Northern Electronics*
Marco Ostrowski
Marco Schugurensky
Marcus Scott
Margo Lauras
Marianna at *Marilyn Minter Studio*
Martha Rose Cronin &
Lionel Skerratt at *Warp*
Mary-Jo at *Lawrence Weiner Studio*
Matt at *Amish Records*
Matt at *RVNG Intl.*
Matt Glenn
Matt Jones
Matthew Daniel Siskin
Matthias Kümpflein
Meora O'Reilly
Michael Cina
Michael Hermann
Michael Minerva
Mike Donovan
Mike Greisch
Molly Smith
Monica Truong
Morgan Canavan
Nadine Bleses
Nathan Burazer
New Atlantis
Nicky Mao
Nicole Miller
Oliver Augst
Olivia Bayley
Omar Ramos
Pam Garber
Patricia at *Blum & Poe Press*
Paul de Froment
Paul Johannes
Penny Yeung
Philipp at *QED Sounds*
Phoebe Emerson
PJ Dorsey
Rachel Gonzales
Randall Uritsky
Raymond Ginn
Renata Kos
Rey Parla
Rian Murphy
Richard Heller
Ritche Desuasido
Rob Bonstein
Rob Shanks
Robbie Clark
Rochelle Leininger
Ruben Boons
Sadie Matthew & *Beggars Banquet*
Sage LaMonica
Sam Gores
Sam Hunt
Samantha Tacon
Samuel Valenti IV
Sarah Womble
Sayaka Sakamoto
Scott Stangenes
Scott Wright
Shaun Gibson
Shlom Sviri
Silvia Gaspardo Moro
Simon Ballard
Simone Shields
Snowy Hanbury

Thank you

Stefan Thull
Stéphane Croughs
Stephanie Adamowicz
Stephen F. O'Malley
Stuart Argabright
Susan Sherrick at *1301PE*
Susie Simmons
Sven Sachsalber
Talia Billig
Terence Hannum
Tessa Morefield
Tim Dahl
Toby Silver
Todd James
Tom Brown
Tomoe Gokita
Tony Fletcher
Tracy Powell
Trevor Hernandez
Ulf Behrens
Vanthi Pham
Victoria Peri
Victoria Roe
Victoria Yarnish
XL Recordings
Yasmine Panah
Zoe Blilie
Zoe King

Special thanks

All the record labels
Alex Da Corte
Alice Cowling
Allison Cooper
artEffect
Barry McGee
Carlo McCormick
Charles Miers
Chris Perez
Chris Rawson
Dan Earl at *BMG*
Darragh Guilfoyle
Dave Muller
David Breskin
David Ellis
Eric White
Experimental Jetset
Genesis P-Orridge
Genieve Figgis
Give a Beat
Harry at *Almost Ready Records*
INVADER & Orbi
James Lavelle & Mo Wax
James McKee
Jeffrey Deitch
Johanna Jackson
John von Pamer
Julian Gross
Marc Auerbach
Marilyn Minter
Martin Mills
Marty Diamond
Matthew Robertson
Matthew Shuster
Patrick North
Paul Gorman
Peter Saville
Richard Russell
Rita Rosenkranz
Robert Diament
Robert Nickas
Rosa Costanza
Ryan McGinley
Sean Bidder & Vinyl Factory
Stanley Donwood
Stephanie Morris
Tauba Auerbach
Theo Elliott
Tom Windish

DB personal thanks

Wini Burkeman
Eve Burkeman
Julie Schumacher
Costanza Prandoni
Reynald Philippe

**Costanza Prandoni
personal thanks**

Camilla Prandoni
Francesco Prandoni
Silvia Papini

**Julie Schumacher
personal thanks**

Brian Finke
James Hoff
Dylan Julian
Daniel McKernan
Olivia Russin

Copyrights

Copyrights

Index

Index